GERMAN VILLAGE

STORIES

BEHIND THE BRICKS

GERMAN VILLAGE
STORIES
BEHIND THE BRICKS

JOHN M. CLARK

The History Press

Published by The History Press
Charleston, SC 29403
www.historypress.net

Copyright © 2015 by John M. Clark
All rights reserved

Front cover: In 1966, a former streetcar barn at 555 City Park Avenue was turned into a boutique shopping mall called Old World Bazaar. This early image is from a photograph postcard that publicized the shops. *Courtesy of the German Village Society.*

First published 2015

Manufactured in the United States

ISBN 978.1.46711.776.0

Library of Congress Control Number: 2015936217

Notice: The information in this book is true and complete to the best of our knowledge. It is offered without guarantee on the part of the author or The History Press. The author and The History Press disclaim all liability in connection with the use of this book.

All rights reserved. No part of this book may be reproduced or transmitted in any form whatsoever without prior written permission from the publisher except in the case of brief quotations embodied in critical articles and reviews.

*For Jan, without whom this book would still be a mostly disorganized boxful of barely legible handwritten notes, hundreds of fading photocopies, close to a thousand photographs and hundreds of miscellaneous files spread across four computers and a handful of USB flash drives. I love you.
And for little Casey Aron Clark, who kept me company every step of the way. I love you, too. (And no, you've had enough treats for now.)*

CONTENTS

Foreword, by Doreen Uhas Sauer — 11
Preface — 13
Acknowledgements — 17
Introduction — 19

Part I: Northwest German Village

121 East Beck Street: The Quaintest Corner? — 25
129 East Beck Street: The Triangle Lot — 26
551 City Park Avenue: The Log House — 27
555 City Park Avenue: Old World Bazaar — 29
559 City Park Avenue: The Millrace — 31
574–576 City Park Avenue: Swabian Nightingales — 34
615 City Park Avenue: Streetlamp with House — 38
645 and 702 City Park Avenue: More Log Houses — 40
151 Jackson Street: Old Fourth Street Schoolhouse — 42
480, 502 and 729 South Third Street: Filling Stations — 44
492 South Third Street: Schwartz Castle — 47
541 South Third Street: Three Bakeries — 49
571 South Third Street: Caterina Limited — 51
576 South Third Street: The Waiting Room — 54
588 South Third Street: The Meeting Haus — 55
595 and 601 South Third Street: Stable and Blacksmith's House — 57
624 South Third Street: Early Society Office — 60

CONTENTS

627 South Third Street: Stauf's German Village — 61
630 South Third Street: Golden Hobby Shop — 62
631 South Third Street and 632 City Park Avenue:
 The Book Loft — 64

Part II: Northeast German Village
169 East Beck Street: Lindey's — 69
180 East Beck Street: The Beauty Parlor — 73
184 East Beck Street: The Pretzel King — 75
192 East Beck Street: Combining Cottages — 76
203 East Beck Street: The Confectionery — 77
228 East Beck Street: Frank Fetch Park — 78
229 East Beck Street: Mathias Lang Home — 80
252 East Beck Street: The Industrial House — 82
291 East Beck Street: The Hidden Treasure — 83
328 East Beck Street: Hurryville — 84
551 South Fifth Street: Lang Stone Yard — 87
645 South Grant Avenue: Beck Place Condos — 88
205 Jackson Street: The Warehouse House — 91
244 Lear Street: Foster Gear Company — 92
548 Mohawk Street: Nature's Door — 94
South Sixth, Lear and Jaeger Streets: Franklin Plating — 95

Part III: Central German Village
804 City Park Avenue: Mission Impossible? — 97
828 City Park Avenue: The Bijou — 98
729 South Fifth Street: Bierberg Bakery — 100
710–712 Jaeger Street: Martin Carpet Cleaning — 102
43 East Kossuth Street: German Village Outhouses — 104
150 East Kossuth Street: Helen Winnemore's — 107
240 East Kossuth Street: Schmidt's Sausage Haus — 110
791 Lazelle Street: Capital Soda Water Company — 113
639 Mohawk Street: Special Addition — 115
673 Mohawk Street: St. Mary's High School — 116
766 Mohawk Street: Hand-Dug Basement — 117
819–821 Mohawk Street: The Old Mohawk — 119
222 East Sycamore Street: Franklin Art Glass Studios — 121
650 South Third Street: Cheese and Ice Cream — 123
664 South Third Street: The Other High School — 125

CONTENTS

739 South Third Street: Max & Erma's Restaurant 127
769 South Third Street: Hausfrau Haven 130
860 South Third Street: Wirtz Brothers Bakery 132

Part IV: South German Village
967 City Park Avenue: Stewart Avenue Elementary 135
1000 City Park Avenue: The Caretaker's Cottage 137
1023 City Park Avenue: A Civil War Coincidence 139
117 East Deshler Avenue and 181 Thurman Avenue:
 The Von Gerichten Brothers 140
133 East Deshler Avenue: A Winning Restoration 144
147 East Deshler Avenue: The "Arm Strong" System 145
100 Reinhard Avenue: The Beer Tent Corner 147
79 Thurman Avenue: The Watch Factory 149
121 Thurman Avenue: Engine House No. 5 151
263 East Whittier Street: Barcelona Restaurant & Bar 153

Part V: Outside the Historic District
387 East Beck Street: The Poorhouse 157
41 West Columbus Street: The Corncrib 159
550 South High Street: South High Street Car Barn 161
966–976 South High Street: Columbus Maennerchor 164
346 East Stewart Avenue: Grosses Bakery 167
767 South Wall Street: A Frank Fetch Restoration 169
280 East Whittier Street: Recreation Park 2 171

Bibliography 175
Index 179
About the Author 187

FOREWORD

In the 1980s, the term "imagined communities" was coined by Benedict Anderson to describe a new way of thinking about nations. He reasoned that no nation is so small that all its members can actually talk face to face; nevertheless, these nations (or communities) generally share a deep comraderie based on similar perceived interests. These communities are "imagined" versus "actual." In much the same way, today's German Village coalesced around a number of shared perceived interests.

German immigrants, who arrived in Columbus as early as Franklinton's roots but came in greater numbers from the 1840s through the 1880s, gave Columbus an amazing and wonderful (but completely unrecognized) gift: the concept of order—no barking dogs or loud and rowdy behavior after 10:00 p.m., there was to be a strip of ground between the sidewalk and the street or curb and front steps were to be kept clean and orderly. In other words, Germans gave Columbus not only biergartens, kindergartens and pork sausages but also the appearance of an orderly and civilized town. This "actual" community stood for civilization in a small, promising nineteenth-century city. But appearance of order also fostered city codes needing enforcement, an awareness of sanitation, an attitude of what went on behind closed doors staying behind closed doors and (more than a little) hubris. Cincinnati lobbied and Columbus pushed at the statehouse and school board doors. Legislation was passed that all Ohio laws must be published in both English and German. Schools were established that mandated all subjects (presumably with the exception of English) be taught in German.

FOREWORD

The push for mandating German was more than just an immigrant whim to stay insular; it was perhaps the only life line to reach a boat that had yet to set sail. German-speaking immigrants had been from not one country (there was no country of Germany until the late nineteenth century) but the many (two-hundred-plus) independent political cities, duchies, dukedoms and principalities that were born out of the Reformation and only later would become Germany. German-speaking families also came from across Central Europe and from the Austrian-Hungarian and Russian Empires. The German language was what united them.

In this way, German Village should represent more than just a mythological or quaint success story but also an ongoing and deliberate historical focus of study, illuminating a Midwest city's travels through the national trends of settlement, immigration, nationalism, industrialization, sectarian divisions, philanthropy, reform movements, the globalization of war and migration. Where do people come from now? Why did some Germans give up on Columbus, move west and found Deshler, Nebraska?

John Clark's work helps to sort out the myths, recognize the stories and look for the history. From barroom brawls to broom factories, the entries can be read in many different ways. In writing this work, he has made the Education Committee of Columbus Landmarks Foundation and our tour-goers very happy. The mission of "Educate to Advocate" has been distilled to "a brick is just a brick unless you know the story behind it." Thank you, John.

DOREEN UHAS SAUER
Columbus Landmarks Foundation

PREFACE

I am a naturally curious person, always have been. And most of the time, my curiosity has served me well. It led me to pursue an education and career in journalism, which I loved. It has also led me to two of my favorite hobbies.

My love of local history started while I was in high school in rural Kentucky, where I researched and wrote a paper on the founding of my little hometown. There wasn't a lot to tell, actually. One of the most interesting facts I discovered was that the preacher who baptized Billy Graham was from my county. You take what you can get. But it must have been a pretty good paper because it earned three A's—one in my high school English class, another one for a college class a couple of years later and, still later, one for my little sister. (I should be ashamed of myself.)

Next, the genealogy bug bit, and I spent hours at a time in libraries and courthouses, poring over census records and death certificates. If I had just been willing to wait for the Internet to come along, I could have saved myself a whole lot of time.

My family history research and oral interviews led to some interesting stories. First, there was great-grandfather Perry, who was divorced by his wife, my great-grandmother. He placed ads for a second wife in various big-city newspapers on Valentine's Day 1904. After a few months of exchanging love letters with a young Missouri schoolteacher, Perry headed west to meet the girl of his dreams against the backdrop of the magnificent St. Louis World's Fair. They were married within days and boarded a train to Kentucky to live happily ever after.

PREFACE

As romantic as it sounds, the story didn't exactly have a happy ending. Apparently, in wooing the young teacher, Perry had greatly exaggerated his wealth, and when his new bride discovered this, she boarded the next train back to St. Louis, never to be heard from again. Relatives told me she left so quickly that her belongings continued to arrive from St. Louis even after she left town. Perry never remarried. He is said to have gone blind in his later years and would spend his days sitting next to a radio, listening to music and softly stroking a stack of those old love letters. I still have them.

Another discovery was even more unsettling. A second great-grandfather—this one on my father's side—enjoyed a stiff drink or two (or three). The story goes that Jake, as he was called, headed home in his horse-drawn buggy one evening, perhaps in the 1920s, after a few hours of drinking with friends. What he did next was never fully explained; relatives were content to blame it solely on the alcohol. As they told it, he pulled his buggy over to the side of the road in front of a churchyard where a man was digging a grave. Jake stepped (or stumbled) out of the buggy; the two men got into an argument, and Jake hit the gravedigger over the head with a shovel. The injury was serious enough to send Jake to prison, where he soon murdered a fellow inmate who had been stealing other prisoners' meals. I do not condone killing under any circumstances, but the murder behind bars made Jake something of a prison celebrity. Relatives later recalled—and boasted—that he didn't receive any extra time for the crime he committed inside. Suffice it to say, I was hooked on these old family stories, and I continued collecting them.

In 1992, my wife, Jan, and I moved to Columbus, Ohio. Our first "home" was a corporate housing unit in Dublin. As for where to settle down for good, my new boss suggested we visit German Village. We did, we loved it and we've been here ever since. Soon, our next-door neighbor got us interested in the local neighborhood association, and we began volunteering for just about every German Village Society fundraiser and special event that came along.

That volunteer work often involved poring over the thousands of historical records collected over the years and preserved by the society. Every house and every business told a story. They fascinated me. If not for an old journal entry or scribbled note on the back of a fading photograph, these stories would have been lost to time—the wife who single-handedly dug the couple's basement while her husband was at work; the "hidden" log houses along City Park Avenue; the notorious Franklin County

PREFACE

Poorhouse, now practically forgotten; the president's father, who once drove a streetcar through the neighborhood; the belief that the bricks on a Mohawk Street home were made with clay from a local Indian mound. Once again, I was hooked.

It is hoped that, just as the family history stories I discovered and preserved are important to me and future generations of Clarks, these recollections of pioneering immigrants might serve to inform and entertain future German Villagers, along with anyone with a love of this historic neighborhood.

ACKNOWLEDGEMENTS

Catherine Adams
Alex Campbell
Scott Caputo
Sue Doody
Jerry Esselstein
Mike Foster
Franklin County Engineer's Office
Jody Graichen
Scott Heimlich
Gary Helf
Carl Jacobsma
Kenneth Lloyd
Brent Martin
Jeff McNealey
Katharine Moore
Doreen Uhas Sauer
Geoff Schmidt
Steve Shellabarger
Shiloh Todorov

INTRODUCTION

The history of German Village has been written many times over. It is well established by now that in 1802, Congress awarded a Scotsman from Nova Scotia named John McGown much of today's historic district for joining the fight for American independence. Some may recall hearing the name Christian Heyl, who was the first German in Columbus, a baker and an early civic leader. We might learn in class or on a field trip that war, famine and unfair inheritance laws drove thousands of Germans to America—and Columbus—between 1840 and 1880. Then there's Frank Fetch, the City of Columbus employee who sparked neighborhood revitalization efforts in the late 1950s and early '60s with a determined rallying call and some early restorations of his own.

But did you know that John McGown demanded a barrel of whiskey from Christian Heyl in return for passage across his land? Or that, determined to rid the town of a nuisance, Christian Heyl organized a two-day squirrel hunt that netted at least thirty-five thousand squirrel hides? Did you know that, though thousands of Germans arrived on the city's South Side, many were just passing through on their way to Nebraska or California? Or that Frank Fetch's first restoration was turning an old corncrib for brewery horses into a cottage suitable for human habitation?

This is not just a trivia book, though. It is an attempt to go "behind the bricks" and tell the human-interest stories that have been locked away in file cabinets and dresser drawers to give you a sense of everyday life here, as witnessed by the residents themselves.

INTRODUCTION

The latest chapter in the history of the South Side began about 1960. That's when residents formed the nonprofit German Village Society, whose name you'll encounter often as you turn these pages. The society, on behalf of the neighborhood, successfully lobbied the City of Columbus for formal recognition of a 233-acre historic district. Shortly afterward came the city-appointed German Village Commission, which oversees exterior changes to homes and businesses. These two accomplishments helped lead to German Village's being placed on the National Register of Historic Places in December 1974.

More than fifty years after it was formed, the German Village Society continues to perform vital functions. It educates residents, students and the community at large about historic preservation. It seeks partnerships with the City of Columbus and other bodies to help maintain the highest standards for our community. It collects and preserves our history and promotes formal discussions about our future. But perhaps just as important, the society serves as the neighborhood's nerve center through which residents meet, socialize, learn, conduct business and help one another.

Make no mistake, this is no Disney version of a quaint, historic community. This is a working neighborhood with groceries and barbershops, bakeries and bars, restaurants and gift shops and, all around those, regular people going about their regular lives. They just happen to do it in a neighborhood whose 150-year-old historic brick buildings and streets, limestone foundations and curbs, horse stables and broom factories have been lovingly restored and adapted for use in the twenty-first century.

To help guide the reader, the seventy-plus stories contained herein have been divided geographically into four sections and then alphabetically and numerically within each section. There is also a fifth section for stories involving people and places just outside the historic district. The stories may be read in any order.

Please note that the term "German Village" is used primarily to describe the 233-acre historic district of the same name. But of course, the early Germans settled a much broader area—generally, from the Scioto River on the west to Parsons Avenue on the east and from a few blocks north of the I-70/I-71split on the north to well beyond today's Nursery Lane historic district boundary on the south. Portions of this book focus on the broader area, as well.

If you grew up in the southern part of Columbus, you probably refer to this broader area as the "Old South End"—or, as the Germans would say, "*Die Alte Süde Ende.*" If you're not native to the area, you more than likely call

INTRODUCTION

it the "South Side." In this book, "South Side" and "South End" are used interchangeably.

Every attempt has been made to resolve contradictions in facts, and to be 100 percent accurate. But written history is only as good as the memories that have been preserved and the author's interpretations of them. If you find a mistake or could add to the stories I've written, I'd like to know about it. You may contact me by e-mail at JCBehindtheBricks@gmail.com. Enjoy.

The German Village Historic District occupies 233 acres just south of Downtown Columbus. *The German Village Society.*

I cannot but think it an evil sign of a people when their houses are built for one generation only. There is a sanctity in a good man's house which cannot be renewed in every tenement that rises on its ruins; and I believe that good men would generally feel this; and that having spent their lives happily and honorably, they would be grieved…to think that the place of their earthly abode…was to be swept away.

John Ruskin, 1819–1900
English author and architecture critic

PART I

NORTHWEST GERMAN VILLAGE

121 East Beck Street
The Quaintest Corner?

Popular Columbus newspaper columnist Bill Arter suggested in 1965 that the corner of East Beck and Lazelle Streets might be the "quaintest" corner in all of German Village. The tiny brick home at 121 East Beck Street is a big reason why. Over the years, residents have expressed the belief that the original two-story structure was once used as a broom factory. While it is true that such small cottage industries could be found all over Columbus's largely ethnic South Side in the nineteenth century, there's no proof to be found concerning the early use of this property other than as a dwelling. In fact, longtime neighborhood resident Dorothy Fischer, herself a German Village pioneer, once remarked that others had referred to it as a former bicycle factory.

What is known is that preservationist Frank Fetch and his wife, Elnora, were so struck by the little building's potential that they bought it in June 1962, barely two years after the formation of the German Village Society, whose primary purpose was to foster and encourage restoration in the neighborhood. The Fetches built a small addition to house a new living room, put in a complete kitchen and bath and added the brick and wrought-iron fence along the northern and eastern property lines. The house was

GERMAN VILLAGE STORIES BEHIND THE BRICKS

The "broom factory" at 121 East Beck Street was once also called the "Paw Paw Palace," for the large pawpaw tree that stood next to it. *The German Village Society.*

used as rental property for the next thirteen years, when the Fetches decided to sell it. Even with the addition, the home contains just 710 square feet, making it one of the most compact properties in the village.

129 East Beck Street
The Triangle Lot

As could be said for many of the properties in German Village, 129 East Beck Street is an unusual site with an interesting history. But if these old houses could argue among themselves about which property is the most unusual, this one would have a point—literally.

Records indicate that the property was used as a stone yard in the 1880s. The two-story, wedge-shaped building you see here today was constructed about 1900 and used as a saloon. The corner door was to entice patrons from two directions at once. The lot is triangle shaped, with only about twenty feet of Beck Street frontage and coming to a point in the rear. Also notable is the

NORTHWEST GERMAN VILLAGE

Looking southwest from the intersection of Lazelle and East Beck Streets. The quaintest corner in all of German Village? *The German Village Society.*

large lamp above the doorway. It is said to be from Edinburgh, Scotland, and once burned whale oil. Over the years, the property has been owned by a peddler, saloonkeeper, woodworker, brewer and streetcar motorman.

But like many of the old homes in the northern part of the village, 129 East Beck Street fell on hard times. In 1958, the city declared the vacant and neglected property "unfit for human habitation." But brighter days were ahead. Restoration work had just begun in 1963 when a couple passing through Columbus en route to Canada caught a glimpse of the house on that summer's Haus und Garten Tour, the German Village Society's signature annual event. It was love at first sight. They bought it just two days later, completed the restoration and moved in.

Over the years, the restored home and garden have received national attention. In August 1965, it was featured prominently in *American Home* magazine.

551 City Park Avenue
The Log House

You may have driven or walked past 551 City Park Avenue without giving the home a second thought. And you would be excused. As lovely as it is,

GERMAN VILLAGE STORIES BEHIND THE BRICKS

The small City Park Avenue log house, covered with wood siding, which Dorothy Fischer bought in 1952. *The German Village Society.*

the small cottage, taken in the context of all the beautiful homes we have in German Village, looks, well, kind of average.

Dorothy Fischer (then Dorothy Dunlap), though, suspected there might be more to the house when she moved to German Village in September 1952 and bought it for herself. Fischer would become a charter member of the German Village Society eight years later, but already, she was showing a keen interest in these old South Side buildings.

To make a long story short, Fischer found handmade nails in the house, which led to the discovery of massive rough-hewn logs beneath the exterior siding. Yes, Dorothy had just bought a log house, right here on City Park Avenue.

In 1957, Dorothy married Ralph Fischer, whom we can thank for a huge portion of the society's photographic archives. The new couple continued to live in the log house for another year before moving on to other restoration projects in the neighborhood.

Among the early residents of 551 City Park Avenue was Jacob Volz, who ran his plastering business out of the house in 1856. In the 1870s, carpenter

Henry Reihl lived here with his wife and seven children. Later, after it had been divided into a double, Peter Brontz (or Prons) and his wife, Marcella, bought the northern half. His occupation is unknown, but Brontz must have prospered. In just a few years, he and Marcella bought the southern half, as well. And it eventually returned to single-family use.

555 City Park Avenue
Old World Bazaar

A German Village shopping mall? Yes, we had one from 1966 until 1985. The location was 555 City Park Avenue in a building constructed about 1891 for use as a streetcar barn, later as the site of a wholesale beer business and then as one of Columbus's first automatic car washes.

The Old World Bazaar, as it was called, was the idea of several early German Village businessmen who were impressed by the resurgence of public interest in the South End. Investors spent about $75,000 to create

In the 1950s, the old streetcar barn at 555 City Park Avenue became Walker's Car Wash, one of the city's first automatic car washes. *The German Village Society.*

GERMAN VILLAGE STORIES BEHIND THE BRICKS

In 1966, the old City Park Avenue car barn became Old World Bazaar, a unique indoor shopping mall with ten boutique shops. *The German Village Society.*

space for ten small shops along a serpentine brick walkway in a building only thirty-five feet wide but about two hundred feet long, stretching from City Park Avenue on the east to South Pearl Street on the west. The complete transformation took only about eight weeks.

Basements were dug for two shops. Another, featuring imported antiques, required a reinforced ceiling to support its centerpiece four-hundred-pound glass chandelier. Other tenants included a gift shop, a candle store, a florist, men's and women's clothing stores, a toyshop and Juergen's Konditorei, the traditional German pastry shop that still operates at 525 South Fourth Street.

Old World Bazaar was successful with locals and tourists for almost twenty years, when changing shopping habits created a business downturn in the 1980s. Since the Bazaar's closing, the building has housed an attorney's office.

A little-known story about 555 City Park Avenue is that it's believed to have been the site of one of Columbus's first churches—one with an adjoining cemetery. And though no one knows for sure, it has been speculated that the first German Village landowner, Revolutionary War fighter John McGown, might be buried in that former churchyard.

559 City Park Avenue
The Millrace

As surveyor for original landowner John McGown's property, John Shields knew a valuable piece of land when he saw it. He liked 559 City Park Avenue enough to pay McGown $200 for it. The way Shields saw it, the little plot had at least two things going for it: a clear, bubbling natural spring and proximity to a flour mill he was building west of High Street.

As was common in the days of water power, Shields's plan was to build a millrace, a narrow channel by which he could send rapidly flowing water to his flour mill in order to turn a water wheel. More than likely, the stream was piped over nearby South High Street. Details of the millrace are scarce, but we're told that water from this spring was also later used by the brewing companies along South Front Street. (And you thought they made beer with river water! This was at a time when much of the city's sewage was still being pumped directly into the Scioto River.)

So what happened to the spring? No one really knows for sure. By the 1860s, the land had passed to George and Margaret Schmitt. They're the ones who built the house you see today. One hundred years later, Ralph and Dorothy Fischer, who lived nearby, bought the now dilapidated house and restored the exterior. Four months after that, in late 1961, they sold it

A view of 559 City Park Avenue prior to its restoration by Ralph and Dorothy Fischer. *The German Village Society.*

for a $6,000 profit—an amount Dorothy called "dazzling." Over the next few years, a fully restored 559 City Park Avenue was featured in several neighborhood home and garden tours.

A note about springs in the neighborhood: We're told Kossuth Street followed a meandering creek bed, and that's why we have that little "jog" at

The same 559 City Park Avenue four months after its restoration. *The German Village Society.*

Kossuth and South Fifth Streets at Schmidt's Sausage Haus. However, area maps from the nineteenth century do not show a spring. Some have speculated that the "jog" has more to do with converging street layouts.

Macon Alley is believed to have once been the site of a creek or stream. And we know that Peters Run wound its way from Downtown Columbus

through the South End and over toward South Front Street. It, too, would be instrumental in the city's brewing industry and in the city's early efforts at a successful sewage disposal system. While other South Side streams have disappeared, Peters Run continues running to this very day. You just can't see it. It's contained in a storm sewer below I-71.

574–576 City Park Avenue
Swabian Nightingales

The early Germans of South Columbus brought with them to this country a keen appreciation of music. Brass bands were a common sight on holidays and other special occasions. And singing societies, including Columbus

Members of the Swabian Benevolent Society pose with the Schiller statue in this 1890s photograph. They led the drive to purchase and install the monument in what is known today as Schiller Park. *Columbus Metropolitan Library.*

NORTHWEST GERMAN VILLAGE

Maennerchor (see 966 and 976 South High Street) and Germania, seemed to spring up all over the old neighborhood.

One such group was the Swabian Nightingales, who rehearsed in a saloon in the north half of 574–576 City Park Avenue. The Nightingales were associated with the Swabian Benevolent Society, a group led by prominent local judge Henry Olnhausen. It was Olnhausen who started the campaign to put an eleven-foot statue of Friedrich Schiller in what was then called City Park. The

The former saloon and home of the Joseph King family is shown here during restoration in the 1960s. *The German Village Society.*

A view of 574–576 City Park Avenue as it appeared after the renovation. Note the small fire mark between the first and second floors. *The German Village Society.*

southern half of the one-and-a-half-story brick double was home to immigrant saloonkeeper Joseph King and his family.

Some records indicate that 574–576 City Park Avenue also housed boarders in its early years. If so, this may have been before the King family grew by six children and the couple literally raised the roof by a full story to make room for them. When contractor Ferdinand Baumann moved the family quarters to the newly built second story, the southern half of the first floor was converted into a "ladies' parlor."

NORTHWEST GERMAN VILLAGE

All the while, King's business was a prosperous one, selling beer by local brewers Hoster and Schlee. He added his booming voice to the chorus of the Swabian Nightingales. And his saloon stayed successful for the next twenty-five years until a pool hall replaced it in 1908. The enlarged building remained in the King family until 1964, when German Village entrepreneur Barry Zacks, who started the Max & Erma's restaurant chain, bought it and converted it into apartments.

So who were the Swabians? Swabians are a group of people in southern Germany who have their own cultural, historic and linguistic characteristics. Many, if not most, of the Germans who settled in Columbus in the nineteenth century were Swabians and Bavarians. While the Bavarians gave us lederhosen, the dirndl and Oktoberfest, we have the Swabians to thank for kehrwoche. This is the centuries-old practice of Saturday house cleanings,

Fire marks usually identified the insurance company with which a building's owner held a fire policy. They could also be purely decorative, as seen here. *Author's collection.*

based on a five-hundred-year-old law. We sometimes read about the South Side German women and their almost obsessive Saturday cleaning rituals. This may have been because of Swabian influence.

Today, this address is also notable for being one of a handful in the village that still displays fire marks. The one at this address can be seen between the first and second floors in the post-restoration photo. A fire mark was a small plaque affixed to the front of a house or commercial building, indicating with which insurance company the owner had a policy. According to urban legend, there was a time when firefighters would pass right by your burning house if you didn't display the proper fire mark. While there was some truth to that in seventeenth-century London, it never worked that way in the United States. Here, fire marks were used primarily as advertising for the insurance companies.

Many of the old fire marks in this country were quite elaborate and are collectors' items to this day. For years, some homeowners have chosen to display replica fire marks as decorations. The one on this building—if it is real—was issued by the Fireman's Association of Philadelphia, which acted like an insurance company. Its policies would not have been issued in Columbus. German Village has at least two other fire marks, real or otherwise. One is at 561 City Park Avenue, and the other is at 793 South Third Street.

615 City Park Avenue
Streetlamp with House

The structure at 615 City Park Avenue has been described as a "'startlingly large' street lamp with attached house." And yes, the fixture is enormous, having once been used to light a street in Amsterdam. Former homeowners Terry and Betty Scherrer fell in love with the lamp decades ago when discovering it in an antique shop. Something told them to hold on to their newfound treasure, and they did—until the mid-1960s, when they bought the lovely, two-story town home that now shares its address.

The house itself is one of the oldest in the village, having been built as early as 1851 by stone cutter Henry Barth. A Columbus police officer with the wonderful name of Heironymous Schweinsberger bought the home in 1865, and it stayed in his family for the next seventy-four years. Mrs. Schweinsberger is said to have kept one of the most beautiful gardens in the

NORTHWEST GERMAN VILLAGE

The large lamp at the front of 615 City Park Avenue once hung above an Amsterdam street. Former homeowners found it in an antique shop. *The German Village Society.*

neighborhood and took weekly trips by streetcar to Greenlawn Cemetery, where she distributed bouquets of flowers among the graves.

As for the Scherrers, who installed the gas lamp, Terry was an attorney and artist. Betty was a published poet and was selected Ohio's "Poet of the Year" in 1936. A poem she wrote about a former home of theirs gained fame

on a nationally broadcast radio program and in the pages of the *Saturday Evening Post*:

> *Do you remember our house, my sweet?*
> *The house with the lamp on Sundle Street?*
> *Two other people have moved there now—*
> *Two other people who made a vow—*
> *But they will wake in a rain-filled night*
> *And listen—and wait—and be filled with fright.*
> *They will hear our talk and our foolish laughter—*
> *And complain of ghosts forever after.*

Despite its rich history, 615 City Park Avenue apparently has remained ghost-free for more than 160 years.

645 AND 702 CITY PARK AVENUE
More Log Houses

So just how many log houses are there in German Village? An earlier story told of the one Dorothy Fischer bought in 1952. (See 551 City Park Avenue.)

Another stood at 702 City Park Avenue. The logs were discovered in 1989, when a new owner stripped two layers of siding from them. There were reports at the time of its discovery that the one-story cabin may have once sat about thirty feet west and had to be moved out of the way when City Park Avenue (then New Street) was laid out early in the nineteenth century. That cabin eventually was moved out of the village, and a new house was built on the site.

In March 2007, a two-story log house that reportedly had been moved from German Village to nearby Lithopolis fifteen years earlier was destroyed in a fire. Some believe it was the house that had stood at 702 City Park Avenue. The time frame for the move would have been about right. But unless a second floor was added to the structure once it reached its new location, that claim is questionable.

Then, there's this unassuming clapboard house at 645 City Park Avenue with vertical siding and a touch of detail along the roof line and lintels (above the windows and door). The lot itself dates back to original landowner John

NORTHWEST GERMAN VILLAGE

In 1992, a new owner stripped away two layers of siding from 702 City Park Avenue to discover it was actually a log cabin. *The German Village Society.*

Looks can be deceiving. This small house at 645 City Park Avenue is actually a nineteenth-century log cabin. *Author's collection.*

McGown and his son, Robert. When Robert died in the War of 1812, the property passed to his widow, Matilda. It then went through several hands, at one time being held by the notable Lyne Starling, a wealthy and generous

real estate broker. It was Starling whose charitable donations played a vital role in establishing a medical college at the Ohio State University.

About 1842, the deed for this lot was passed to a gardener named Barnhart Reiter. We know Reiter had been renting the land and cabin for a few years prior to his purchase. So, while we don't have an exact year of construction, it's safe to say the log house is at least 172 years old as of this writing (2015). That would make 645 City Park Avenue a strong contender for oldest house in German Village.

151 Jackson Street
Old Fourth Street Schoolhouse

In December 1967, the City of Columbus lowered the boom (quite literally) on what it thought was the oldest existing school building in the city. School board records show that land for the Central German-English Grammar School at East Fulton and South Fourth Streets was purchased in 1853. But it would be another nine years before the first of two multistory brick buildings was constructed. The second building followed just a few years later.

At the time, the location was considered the heart of the city's growing German community, and the school reflected the local population's needs. German was spoken in the classrooms, and all textbooks were printed in German. The school also served as the center for social life in the neighborhood. Toward the turn of the century, though, as second- and third-generation Germans were leaving the South End and fewer people were speaking German at home, the language requirement was dropped and the name changed to Fourth Street Elementary.

The school continued serving the area until 1953, when the facilities were abandoned and the student body was transferred to the new Mohawk School at Livingston and South Sixth Streets (later to become the Africentric High School). A year later, the property was sold at auction to the adjoining Heer Printing Company to be used for storage. The old playground became a parking lot.

Then, in 1967, the City of Columbus ordered that the old school building be demolished as part of the huge Market-Mohawk urban renewal project. What had taken years to build came down in a matter of hours. Today, coincidentally, the site is occupied by the new Columbus Downtown High School.

NORTHWEST GERMAN VILLAGE

The remaining building of the Fourth Street Schoolhouse awaits demolition in this 1967 photograph. *Columbus Metropolitan Library.*

As the old school was nearing demolition, talk in the community turned to what it had looked like in its earliest days. Some seemed to recall hearing about a small, one-story frame schoolhouse that stood in a corner of the lot between the time when the land was purchased and the first brick building went up. In a 1955 letter to the *Columbus Dispatch*, an elderly woman wrote that her mother had attended the German-English School and that she had confirmed the existence of the little frame school building. Her mother had told her it was torn down at the time the first brick building was going up. Case closed. Or was it?

Nine days later, on January 14, 1955, the *Dispatch* printed a second letter. This one, from a former South Side resident, caused quite a buzz in the old neighborhood. John Lorenz wrote that the original Fourth Street Schoolhouse had not been razed but had been moved about two blocks south to the southeast corner of Jackson and South Fourth Streets in what is now German Village. Lorenz said his father had bought it in 1887, presumably

GERMAN VILLAGE STORIES BEHIND THE BRICKS

The living room of this house at 151 Jackson Street served as the original Central German-English Grammar School. It was moved to this location about 1862. *Author's collection.*

from the man who had moved it, and that it had been enlarged to become a three-room home.

The white frame house at 151 Jackson Street has passed through almost a dozen hands since John Lorenz grew up in it in the 1920s and '30s. Chances are few of them knew their living room had been a pre–Civil War schoolhouse.

480, 502 AND 729 SOUTH THIRD STREET
Filling Stations

South Third Street has sometimes been referred to as the "Main Street" of German Village. And what is Main Street without a gas station or two—or three? There was a time when you could have your tank filled, your oil checked and your tires aired up at any of three full-service gas stations on South Third Street between Livingston Avenue and East Whittier Street.

The most recent one to have closed its doors was a BP station at the southeast corner of Livingston Avenue and South Third Street. Built about 1962, the station carried the Sohio brand for years until switching to BP in 1990. As soon as BP took over, there were discussions about modernizing the facility by adding a convenience store. But the oil

NORTHWEST GERMAN VILLAGE

A gas station on the southeast corner of South Third and Livingston Streets. It was replaced by an office building about 1996. *The German Village Society.*

Sidney Roy's Phillips 66 station at 502 South Third Street. In 1979, a second floor was added, and it became an office building. *The German Village Society.*

company couldn't see eye to eye with German Village's architectural review board, the German Village Commission. Apparently, the society board harbored some ill feelings, as well. In November 1991, President

Fred Holdridge wrote to the BP chairman, saying, among other things, "We would welcome the disappearance of the station."

There were further discussions between the oil company and the commission, but nothing ever came of them. In 1993, BP removed its pumps and vacated the property. For a while, the corner served as a parking lot for nearby Katzinger's Delicatessen. Finally, a demolition authorization was granted in late 1995, the lot was leveled and a two-story office building soon took its place.

Pre-dating the station on the corner by a dozen years was one just three doors south, at 502 South Third Street. Known for most of its existence as Sidney Roy's Phillips 66, the business changed hands a couple times in the late 1970s. And then, someone began floating the idea of closing the station, removing the pumps and underground tanks, adding a second floor to the building and turning it into offices. And that's exactly what happened in 1979. Apparently, this wasn't the first building on the site, though. Several years ago, one longtime resident of the neighborhood said there had been a run-down rooming house on this corner about 1900.

As early as 1899, a brick building—most likely a small house—stood on the northwest corner of South Third and Frankfort Streets, across from what is now the original Max & Erma's Restaurant. By 1932, though, it was a vacant lot. And then, beginning in 1940, it was the site of a succession of gas stations.

Seen here as the former Manda's Sinclair Service, 729 South Third Street received a makeover in 1979 and became a small office building. *The German Village Society.*

First, it was the Walter S. Young Filling Station. Vogel's Sinclair Service took over in 1965. And by 1968, it had become Manda's Sinclair Station, where Bert Manda handed out S&H Green Stamps with the purchase of a few gallons of gas or a car wash. Later abandoned, the old building received a complete makeover in 1970, when it was turned into a small office building.

492 South Third Street
Schwartz Castle

Perhaps the most unusual home in German Village, Schwartz Castle holds more than 130 years of speculation and unfounded rumors. The stately home was built about 1880 for Friedrich Wilhelm Schwartz, a recent German immigrant who owned a successful apothecary shop at East Main and North Fourth Streets.

As an enlightened man of medicine, Schwartz was a follower of the nineteenth-century "sanitary movement," which sought to slow the spread of disease by keeping a clean physical environment. Schwartz installed sanitary and easy-to-clean surfaces, including tiled walls and iron stairways. He also believed in an abundance of fresh air and designed his home with a flat-roofed turret, where he enjoyed daily sunbaths—some say in the nude.

For years, we've been led to believe that Schwartz was beyond eccentric. We're told that he became a little unhinged when a fiancée back in Germany broke off their engagement, that he died alone at age seventy-four and that his body went undiscovered for weeks. None of it is true. There was no fiancée. His sister lived with him until his death. Columbus mayor George Karb counted Schwartz among his friends and even served as executor of the Schwartz estate.

So maybe the old man did take long, barefoot walks, perhaps even in the snow. Yes, he was a vegetarian. He may have preferred wool clothing against his skin, and he may very well have preferred drinking rainwater. Hardly enough evidence for him to be called "crazy."

After sitting vacant for the next three years, the "castle" found other uses. In 1917, it became the home of the Columbus Maternity Hospital. When the hospital closed, the building fell into disrepair and was often vacant and boarded up. In the mid-1950s, while serving as a seedy rooming house, the property received attention for two murders that occurred here. Then, in the 1960s, the city condemned the house, and it faced demolition. But fate intervened.

GERMAN VILLAGE STORIES BEHIND THE BRICKS

The elaborate, castle-like home of druggist Friedrich Schwartz, at 492 South Third Street, was built about 1880. *The German Village Society.*

NORTHWEST GERMAN VILLAGE

Business partners Bob Echele and Bob Gease bought the building in 1973, gutted it, restored it and completed the fourth floor. Echele and Gease added a ballroom, a movie theater, a private elevator and more, with the idea of renting the upper two floors. Realtor Mike Ferris, who bought the property in 2003, reportedly spent hundreds of thousands of dollars on further improvements. Later, following a short period of bank ownership in 2010, Schwartz Castle returned to private hands in December 2011.

541 SOUTH THIRD STREET
Three Bakeries

The first recorded use of this property was for Greenley Dill's brick-making business in 1843. As you might have expected, bricks were in high demand here in those days. In fact, as late as 1872, South Columbus boasted thirteen brickyards in all, using local clay to bake about twenty million bricks a year.

Workers for Reiner's Doughnuts are shown in this 1930s photograph posing in front of the first of three successful bakeries to occupy this site. *The German Village Society.*

49

Thurn's Bäckerei had a successful thirty-year run in this building prior to its closing in 2004. Pistacia Vera took over the site three years later. *The German Village Society.*

It's not known how long Dill's business lasted. But by 1930, a different kind of bakery was in operation here. Reiner's Doughnuts, owned by German immigrant Gottlieb "George" Reiner, relocated to this address from just one block north. George Reiner's doughnuts and cakes were popular for the next forty-four years, and the shop made a lot of them during that time using a special machine to turn out up to 960 doughnuts an hour.

Another German Village institution followed when the Will Plank family bought the building in 1974 and began operating Thurn's Bäckerei, named

in honor of Will's in-laws. Bakery number three came along thirty-three years later when siblings Spencer Budros and Anne Fletcher made extensive renovations to the old building and began selling handcrafted pastries at the stylish and sophisticated Pistacia Vera.

One more note about the use of bricks in South Columbus: Some of the clay used for early buildings here was taken from old Indian mounds. That's why there's no longer a mound on Mound Street. Clay from that Indian mound was used to make bricks for Columbus's first statehouse. Legend has it that when that first statehouse burned in 1852, many of the bricks were carted off for use in building a home on Mohawk Street. Even if that's true, we may never know which house it is.

571 South Third Street
Caterina Limited

One of the best surviving photographs we have of everyday life in nineteenth-century German Village depicts the southwest corner of South Third and Beck Streets about 1888. Directly on the corner is a large, three-story brick building that, at the time, housed Frank Schmitt & Son Grocer (or, as the side of the delivery wagon reads, "Schmitt & Schmitt"). Windows are open on the second floor, where the proprietors would have lived. The old man in the left window is unidentified; perhaps it was Frank Schmitt himself. A basket of produce sits on the hitching rail to the left of the front door. And if you look closely to the right of the young woman, you may be able to make out a display of brooms—four or five in all, maybe from the nearby broom factory on Lazelle Street. We know that in later years an organization known as the Swiss Home Association had its offices on the second floor, and the Swiss Singing Society hosted concerts and parties in the third-floor hall. The address above the door, "451," would soon change to "571" as part of a citywide house renumbering program.

Next door to the grocery, we see a one-and-a-half-story, brick-like cottage with the sign "Lager Beer" above the doorway. Obviously, this was a "bierstube," a German-style indoor tavern. It has been written, perhaps with a certain amount of conjecture, that workers walking home from the breweries along South Front Street would stop here for libation and a brief respite before proceeding on to their cottages along Beck Street and beyond.

GERMAN VILLAGE STORIES BEHIND THE BRICKS

The southwest corner of South Third and Beck Streets in the late 1880s. *Left to right*: a butcher shop, a beer tavern and a grocery. *Courtesy of Kenneth Lloyd.*

Opposite, bottom: Haus und Garten Tour visitors enter the Peerless Saw Company at 571 South Third Street in this 1960s photograph. *Courtesy of Catherine Adams.*

Just south of the bierstube stands another important business: the butcher shop. The sign hanging by the door reads, "M. Siegle—Daily Meat Market." By this time, there were certainly enough slaughterhouses in the South End to provide the shop with at least beef and pork and perhaps other meats, as well.

What happened here before this period is not so clear. It has been recorded that in 1838, a tobacconist named Charles Winn bought a small house on this corner and that by 1870, Frank Koehler was running a "modern" grocery here, where he served a rare treat for the time: ice cream.

The 1879 *Columbus City Directory* puts the Schmitt Saloon in the three-story building. And by 1888, C.&G. Deibel's Saloon occupied the old bierstube.

A wave of changes hit the corner in 1931, when Bernie Hodapp and four business partners opened the Peerless Saw Company here. At first, they offered only sharpening services. Then, in the late 1940s or early '50s, records indicate the company may have combined the two next-door buildings into

NORTHWEST GERMAN VILLAGE

The Peerless Saw Company is seen in this photograph of the southwest corner of South Third and Beck Streets. Date unknown. *Courtesy of Catherine Adams.*

one and replaced the two pitched roofs with a flat one. This became a small factory where Peerless saw blades were made.

The company operated here until 1979, when it moved to larger and more modern facilities in Groveport. The three-story building then served as offices for other businesses until 2006, when German Village resident Catherine Adams moved her European housewares store, Caterina Limited, here from a smaller space nearby. She displays artwork on the two upper floors while a law firm has offices in the converted one-story factory and the two-story brick Italianate next to it.

By most outward appearances, the three-story corner building looks much the same 125 years later. As for the hitching rails, the ones that helped hold up the produce basket in the photograph of the old grocery, they're still here, too. However, these days they're mostly used to secure bicycles and dogs.

576 South Third Street
The Waiting Room

This stately, two-story house at South Third and Beck Streets has many features you would expect in a German Village Italianate—a stone foundation, brick walls, slate roof and ornate lintels—and one not-so-common element: a rather odd-looking protrusion just south of the main entrance.

The house was built about 1880 for Dr. and Mrs. Myrwood Dixon. Dixon began operating his medical practice out of the new home and added the extension in the late 1890s as a waiting room for his patients.

Dixon, who died in 1952 at the age of eighty-nine, was known to patients throughout the South End. He never hired a nurse or a receptionist. If you needed to see him, you would simply enter the waiting room through the separate exterior door and take a seat until it was your turn.

Sick people would continue to show up at the house, even after Dixon died and the property had passed to interior designer Louis Yumet and his wife, Virginia, in 1958. Yumet answered his door once in the late '50s and looked straight into the eyes of a pregnant teenage girl. She told him her mother had sent her for a check-up, not knowing the doctor had been dead for years.

The home changed hands several times after that, becoming law offices in the 1970s and returning to private residential use in 2005.

The former home of Dr. and Mrs. Myrwood Dixon is seen in this photograph, taken during a Haus und Garten Tour in the 1960s. *The German Village Society.*

588 SOUTH THIRD STREET
The Meeting Haus

Was there hanky-panky at the Meeting Haus? Quite possibly! Since 1991, the building at this address has served as the headquarters of the nonprofit German Village Society. But it opened in 1923 as a lodge for the Fraternal Order of Moose. Members conducted business downstairs and often held parties and dances in the second-floor hall.

In 1942, the Moose Lodge traded properties with a Woodmen of America office at South Front and Sycamore Streets. Woodmen members, now meeting on South Third Street, did not condone drinking or gambling, but there were the occasional reports of "girlie shows" on the second floor. Thomas Littleton bought the property in 1960 and turned the building into a sign shop. He added a garage and parking lot on the west side of the structure, and the address changed from 120 Willow Street to 588 South Third Street.

Fast-forward to 1987, when the German Village Society was outgrowing its office at 624 South Third (see 624 South Third Street) and its Meeting

GERMAN VILLAGE STORIES BEHIND THE BRICKS

Littleton's Sign Shop at 588 South Third Street prior to its purchase by the German Village Society. The garage portion is today's Visitors' Center. *The German Village Society.*

Today's German Village Meeting Haus opened in 1991. Society members raised more than $500,000 in donations for its total renovation. *Author's collection.*

Haus at 138 East Columbus Street. A committee was formed to find a new home to serve both functions, and it settled on this property, which Littleton had recently placed on the market.

The society sold its East Columbus Street property and, two weeks later, bought this one. That's when the real work began. Members spent the next few years raising a half million dollars in donations for an extensive renovation project, designed by William Hugus Architects. Doors were finally opened to the public in August 1991. Since then, 588 South Third Street has served as offices for the society and has hosted hundreds of German Village Society and Commission meetings, along with community potlucks, fundraisers, holiday celebrations, concerts, art shows, Halloween parties, weddings, funerals, private events and more. The Visitors' Center, itself located in the former sign shop's garage at the front of the building, welcomes upward of fifteen thousand visitors to the neighborhood each year.

Interestingly, the building played host to some very early German Village Society and German Village Commission meetings, back in the days when the organization had yet to establish a permanent home—and even longer before members ever dreamed of owning it. But those meetings came with a price. It has been said that former owner Littleton, a bit suspicious of any organization with the word "German" in it, first required a signed statement that said the groups had no nefarious intentions.

595 and 601 South Third Street
Stable and Blacksmith's House

For years, the two-story brick building at 595 South Third Street has been referred to as an old blacksmith shop. But there's more to the story. The building, which has also housed an ice cream parlor and upscale restaurants, was built in the 1880s as a horse stable and blacksmith's shop. Hay wagons would pull up to the Willow Street side of the building, where workers would hoist the hay through a second-floor window into the haymow, or hayloft.

A blacksmith named John Waldschmidt owned the building, along with the small brick cottage directly across from it at 601 South Third Street and a wooden shed behind the house. It was here in the shed that Waldschmidt and other workers forged and shaped additional horseshoes.

GERMAN VILLAGE STORIES BEHIND THE BRICKS

Above: This 2015 photograph shows John Waldschmidt's old house (601 South Third Street) on the left and his stable (595 South Third Street) on the right. *Author's collection.*

Left: The building at 595 South Third Street later housed a successful ice cream shop, the Golden Eagle, followed by a succession of restaurants. *The German Village Society.*

58

NORTHWEST GERMAN VILLAGE

This iron ring, to which horses were secured, can still be seen today at 595 South Third Street inside G. Michael's Bistro and Bar. *Author's collection.*

In 1977, an elderly woman who grew up in the neighborhood reminisced about walking past the shed when she was a little girl. She's quoted in the German Village Society's newsletter as saying, "Kindly, buxom Mrs. Waldschmidt would come to the back door (of the house) and ring the lunch bell for her son. (Otherwise), he couldn't hear her voice over the noise of the flange, the roaring flame under the bellows, and the clanging of the hammer on the anvil and red-hot horseshoe."

Today, the shed is long gone. But the house is still there, now used as a dentist's office. The old stable houses office space on the second floor and G. Michael's Bistro and Bar on the first. Little evidence of its original use remains, except for a row of iron hitching rings set in the exposed brick of the bar's northern wall. Most are hidden behind customer seating, but one is clearly visible near the hostess stand.

GERMAN VILLAGE STORIES BEHIND THE BRICKS

624 South Third Street
Early Society Office

By 1961, just one year after its formation, the German Village Society had raised enough money to buy a parcel that included this small brick cottage and the double directly behind it. The organization had been

Visitors line up to buy Haus und Garten tickets at 624 South Third Street in this photograph from the 1960s. *The German Village Society.*

Newspaper columnist and early neighborhood supporter Ben Hayes (in glasses) helps society members peel turnips for turnip kraut in cramped offices at 624 South Third Street. *The German Village Society.*

NORTHWEST GERMAN VILLAGE

using borrowed space to conduct its business for more than a year when it became obvious that the growing nonprofit group needed a permanent home. The society paid $6,000 for all three addresses, renovated the double and eventually sold it. It would call the little cottage in front "home" for the next thirty years.

When the German Village Society moved to 588 South Third Street in 1991 (see 588 South Third Street), the cottage became headquarters for the group's annual Oktoberfest fundraiser. It was put up for sale in 2006 and has since been restored for use as a private home.

627 South Third Street
Stauf's German Village

You can't believe everything you read. Look to the top of 627 South Third Street, currently a Stauf's coffee shop, and you'll see "Since 1885." But it's widely believed that the building didn't go up until about six years later. Why the discrepancy?

Carl Magnuson's frame shop at 627 South Third Street in the 1970s. The building received a new façade before becoming a savings and loan office in 1977. *The German Village Society.*

The "1885" refers to a business, not the building itself. But what business? The building opened about 1881 as a saloon with second-floor living quarters. And it stayed a saloon for the next several decades. By 1932, the Best Wallpaper store had taken over.

It isn't clear what came next. But in 1961, Carl Magnuson moved his family's picture framing studio here and added a simple new stucco façade to the building. Magnuson's was highly regarded, having been in business at other locations since 1898. A newspaper columnist who just happened to have been Carl Magnuson's college roommate once wrote, "Through their doors pass more mink coats than most any place in Columbus." He also chided the owner for slow turnaround times but said the final product was well worth the wait.

Magnuson's closed its German Village doors in 1976, making way for a branch office of Railroad Savings & Loan, which had been in a smaller office just down the street. Railroad embellished the façade, adding the features you see today, including the "Since 1885" sign. When Diamond Savings Bank took over in the 1980s, the façade—and the sign with the date—remained.

And it's been there ever since, through its time as the Nutcracker gift shop, the Pellington Gallery, the original Cup O' Joe coffee shop and now Stauf's German Village—none of which had even been conceived of in 1885.

630 South Third Street
Golden Hobby Shop

Not to be confused with St. Mary's Church and School a few doors south, the large, two-story brick building at 630 South Third Street was a Columbus public school. The Third Street German-English School, as its name implied, served the needs of the South End's large German-speaking population, starting in 1866.

From its beginning, led by Principal Carl Becker and a staff of "seven lady teachers," the Third Street German-English School prided itself on more than simply educating its children in the three Rs. The faculty also worked hard to instill in the students a sense of pride in their community and high moral values.

To this day, Columbus Public Schools maintains a large number of files on the old school, including essays and poems written by the students. In

NORTHWEST GERMAN VILLAGE

An early sketch depicts the south side of the Third Street German-English School, which opened its doors at 630 South Third Street in 1867. *The German Village Society.*

The Golden Hobby Shop, a city-owned consignment crafts store for seniors, in 2015. This is the view from South Third Street. *Author's collection.*

1886, twelve-year-old Ida Bauer wrote this about life in general: "The best rule by which to go through life with beautiful manners is to feel that everybody, no matter how rich or poor, needs all the kindness that others in this world can give."

Reporting on the school in 1900, the Columbus Board of Education had high praise for both its academic achievements and its excellent appearance. And at the time of its closing in 1976, the Third Street School (having dropped the "German-English" from its name) was the oldest operating Columbus public school.

There were various proposals about what to do with the building; thankfully, demolition was never seriously considered. The Greater Columbus Arts Council, which had been housed in the Laveque Tower, spent a short time here beginning in 1979. And for a time, the German Village Society considered moving its offices here from its cottage a few doors away.

In 1980, the City of Columbus paid $250,000 for the building, completely renovated it and made it the permanent home of the popular Golden Hobby Shop. Golden Hobby is a consignment craft shop for senior citizens, which also offers workshops, demonstrations and quilting classes. Any Ohio resident aged fifty or over is allowed to be a consignor. A friendly staff of volunteers keeps the operation going year-round.

631 South Third Street and 632 City Park Avenue
The Book Loft

In the mid-1970s, Carl Jacobsma and Roger Tompkins began selling books at their tiny Village Owl gift shop on City Park Avenue. The little store—actually a small, one-and-a-half-story brick cottage—did well. So in 1977, their friend Marian Southard—or Marnie, as she liked to be called—asked them to join her in a nearby retail venture. The partners took Marnie up on her invitation, setting off a chain of events that eventually led to today's Book Loft, a huge and eclectic independent bookstore that tops just about every German Village visitor's "To Do" list.

But to properly tell the Book Loft story, we must start one hundred years earlier. In 1877, 631 South Third Street opened as Maurer's Saloon, owned and operated by Amelia Maurer. It was a two-story brick commercial

NORTHWEST GERMAN VILLAGE

The Village Owl gift shop at 561 City Park Avenue was a forerunner to today's massive thirty-two-room Book Loft, directly across the street. *The German Village Society.*

building, with an alley along its southern edge, built on what once had been farmland. Living quarters occupied the second floor of what was then called the Substantial Building. When Prohibition arrived, the address turned to other uses. It was an early nickelodeon, called the Lily Cinema. Later, it became Mrs. Keller's Doll Hospital and Variety Store, a huge hit with children from the two schools across the street. Over time, the building would also see use as a church, a decorating company, an art studio and

GERMAN VILLAGE STORIES BEHIND THE BRICKS

Marianplatz, a popular tourist destination in the 1970s, housed a half dozen small shops at 631 South Third Street, the site of today's Book Loft. *The German Village Society.*

school, an indoor golf course and, if memories serve some correctly, an early Kroger grocery store.

Against this backdrop, Marnie Southard, in 1968, rented one room of the building and opened a flower shop. But before long, her plans turned much more ambitious. She and her husband, Ollie, bought the building and replaced the flower shop with Marnie's Arts & Antiques, selling everything from Hummels to antique beer steins. Next, she divided the rest of the large building into six small shops, all facing a new garden path where the alley had once been. She called the little mall Marianplatz, a Fussganger Gallery of Shops (*fussganger* meaning a "pedestrian walkway"). Marianplatz was soon home to a jewelry store, a candy store, a florist, a card shop and more.

With the success of Marianplatz, Marnie turned her attention to another two-story commercial building, this one directly behind hers, facing City Park Avenue. The building at 632 City Park Avenue had had its own colorful history, opening as Wolf Tavern in the nineteenth century and then becoming the Berkley Saloon, followed by, for more than one hundred years, a variety of small groceries. Marnie bought this building as well and opened a second gift shop at the City Park end of her property. Logically, the next step was to build a small "connector" store to join the two buildings into one block-long retail mall. And that's just what she did.

A 1970s view of 632 City Park Avenue. About 1977, this building was connected to 631 South Third Street, creating a block-long retail shopping destination. *The German Village Society.*

Now, back to the Book Loft and Marnie's invitation to the Village Owl shop owners to join her. They decided to take the risk and opened their first full-fledged bookstore in the new Marianplatz connector, where today you'll find the store's main entrance. Business continued to be strong. But the little

GERMAN VILLAGE STORIES BEHIND THE BRICKS

The Book Loft is one of the nation's largest independent bookstores. It has been a popular German Village destination since it opened in 1977. *The German Village Society.*

shops around the bookstore tended to come and go. So, as a neighboring store moved or went out of business, Tompkins and Jacobsma would tear down a wall and expand. They did this at least eight times over the next fifteen years until the entire building—all thirty-two rooms—was theirs.

Today, the Book Loft is one of the premier destinations for German Village visitors. Newest partner Russell Iler, the shop's book buyer, makes sure there's always something new and exciting around every turn. And with thirty-two rooms, there are plenty of turns. And that, perhaps, is the Book Loft's biggest attraction—a multistory, block-long shop where it's fun to lose yourself for a couple of hours. (But don't worry, maps are available at the front door.)

There doesn't appear to be a particularly slow period here. But when the weather is warm and people are enjoying their German Village visit, it might be best to avoid Saturdays. That's when, its owners say, the Book Loft can count on up to three thousand shoppers. Yes, in one day.

Part II

NORTHEAST GERMAN VILLAGE

169 East Beck Street
Lindey's

Few commercial buildings in German Village have seen more occupants over the years than 169 East Beck Street. Art Daeumler built the two-story structure in 1884, operating a grocery on the first floor and, more than likely, raising his family on the second. By the turn of the century, Daeumler's Grocery had become the Daeumler and Olnhausen Saloon. In 1902, the Daeumler family opened a meat market across the street on the southeast corner of East Beck and Mohawk Streets. Then, in the early 1900s, the nearby Gambrinus Brewing Company opened the Tide House Saloon here. The name was a play on the words "tied house," which meant that the establishment was "tied" to a particular brewery and could sell only its products.

With the passage of Prohibition, a hardware store moved in, along with, as some have claimed, a speakeasy. Others have said a flower shop also operated here for a while during that period. Once Prohibition was repealed, a number of drinking and dining establishments came and went: King's Rose Garden, Albert P. Grubbs (with rock music and video games), Barney's, the Palmer House, the Lindenhof and, since 1981, Lindey's Restaurant & Bar.

German Village resident Pat Phillips remembers the King's Rose Garden era in the 1950s for the violence that was often reported there. Riding the

GERMAN VILLAGE STORIES BEHIND THE BRICKS

Outside 169 East Beck Street, probably during its time as the Daeumler and Olnhausen Saloon, a Columbus Brewing Company sign hangs by the door. *The German Village Society.*

King's Rose Garden, at the southwest corner of East Beck and Mohawk Streets, as it appeared in the 1940s. *The German Village Society.*

NORTHEAST GERMAN VILLAGE

Inside King's Rose Garden in the 1940s or '50s. The building was sometimes called the "Bucket of Blood" for the violence that was often reported here. *Columbus Metropolitan Library.*

school bus home one afternoon, Pat remembers the bus driver stopping at East Beck and Mohawk Streets and ordering all of the children to the floor. A gunfight had just erupted outside the bar, with about thirty shots being fired.

Pat says a few years later, when he was about fifteen, he and a friend were playing cards in the Rose Garden one day with the men from the second-floor rooming house. A woman burst through the doors with a gun, stopping directly in front of a gentleman seated at a table next to Pat's. He recalls the woman saying something to the effect of, "So this is where you've been spending all our money!" She raised the gun and shot the man dead. Pat dove under his table and stayed there until a policeman tapped him on the shoulder and told him to go home. (Apparently, the police had more important matters on their minds than underage beer drinking.)

Nothing of that sort has been reported since 1981, though, when restaurateur Sue Doody opened Lindey's, which is generally regarded as one of the finest restaurants in Central Ohio. Of special note are the modern (but styled after those of the pre–Civil War era) pressed tin ceiling, French chandeliers, solid walnut doors from the city's old Alcorn Mansion (the home

GERMAN VILLAGE STORIES BEHIND THE BRICKS

Above: Lindey's gets its name from a large linden tree that once grew on the property. Owner Sue Doody has since planted a new one. *Author's collection.*

Left: Future governor John Kasich and villager Pat Groseck join a citizens' brigade in 1984 to help repair brick streets. *The German Village Society.*

of two prominent doctors named Alcorn) and the bar from the third—and last—Neil House Hotel downtown.

However, Lindey's served as the backdrop for a media circus that occurred in March 1984. Fed up with the number of potholes in the surrounding brick streets, a small group of protesters led by village activist Fred Holdridge planted a tree in an especially deep pothole on Beck Street right in front of the restaurant. This led to a pledge by the city to take better care of its historic streets, replacing brick with brick and not simply patching holes with asphalt. Inspired by the city's decision, neighbors and civic leaders joined municipal workers over the next few weekends, helping them with their repairs.

180 East Beck Street
The Beauty Parlor

The Franklin County auditor's online records for this address, and virtually every other address in Columbus, date back only as far as 1920. There is little doubt, however, that this two-story brick home is much older. Over the years, it has served both residential and commercial purposes. Some neighbors have recalled the time when a beauty parlor occupied the first floor. Markings on the

The structure at 180 East Beck Street as seen in the mid-twentieth century. It has served as both a private residence and as a retail business. *The German Village Society.*

The restored and enlarged home at 180 East Beck Street, as seen in 2015. *Author's collection.*

brick seem to indicate the one-time presence of a large picture window. And for many years, the building was painted white.

But big changes were on the horizon when, in 1999, two men bought the property and began a full restoration. First, the white paint was removed, revealing the natural brick exterior. A dilapidated, non-historic garage behind the house was demolished and replaced by a combination two-story garage and carriage house. A tunnel, doubling as a wine cellar, was dug to connect the main house to the new structure in the back.

Great care was taken in renovating the home's interior, as well. Architect William Hugus replicated the original baseboards, doors and window casings. Wood windows were replaced. No detail was too small or too big, including custom-made door hinges and knobs, French-designed house numbers by the front door and a concealed second-story "safe room."

NORTHEAST GERMAN VILLAGE

184 East Beck Street
The Pretzel King

One might be surprised by the number of newer homes in German Village. Perhaps as many as a dozen new single-family houses were built in the twenty-five years prior to 2015. If designed thoughtfully, with an eye toward integrating the new with the old, you might not even notice they're new.

This modern four-thousand-square-foot home was built on the site of "Kinzig, the Pretzel Maker's" house in 1999. *Author's collection.*

One such home is 184 East Beck Street, built in 1999 by Brett Cambern and his wife, Andrea, a popular longtime news anchor at CBS affiliate WBNS-TV in Columbus. This was the first of two new builds on East Beck Street for the former German Village couple (see 252 East Beck Street). This four-bedroom, three-bathroom Italianate contains more than four-thousand square feet of living space, with ultra-modern amenities throughout.

This wasn't the first home on the site, though. That distinction apparently goes to a two-story, Civil War–era frame house that has since been lost to time and, perhaps, fire. The owners were Augustus Wagner Kinzig and his wife, Krezenzia Baier Kinzig. A great-granddaughter of the couple would later recall that Augustus was known as "Kinzig, the Pretzel Maker," and that Krezenzia made and sold noodles out of their home.

The *Columbus City Directory* of 1887 places the Kinzig bakery at 134 East Beck Street, an address that may have been near Lazelle Street but no longer exists. In a move that continues to confound local historians, the U.S. Postal Service "realigned" city addresses in 1862 and again in 1888. Many South Side street names have changed since 1888, sometimes more than once. But thankfully, house numbers have remained the same for more than 125 years.

192 East Beck Street
Combining Cottages

German Village is full of single-family homes that started out as two, sometimes even three, individual properties. Such is the case with 192 (and the former 196) East Beck Street. Built about 1885, the two cottages were owned by the same extended family. And for a while, they were connected by a makeshift doorway. Eleanor Alvarez bought the two properties in 2007 (along with a duplex in the rear) and, with architects Behal Sampson Dietz, began planning to make the connection permanent.

Today, through thoughtful design work, the only indication from the street of a connection is a narrow recessed floor-to-ceiling window between the two formerly separate houses. The western half of the home features a large dining room, kitchen, butler's pantry and wine bar.

The eastern half has a great room with vaulted ceiling, office and bathroom. An added sunroom connects the two older homes to a new, two-

A narrow floor-to-roof window is the only outward indication that these two cottages have been combined to form a new single-family home. *Author's collection.*

story addition at the rear. That portion houses a two-car garage, a second-floor master suite and a sundeck. The total living area went from about 2,400 square feet (for the combined cottages) to 4,000 square feet.

203 East Beck Street
The Confectionery

Small, home-based groceries and confectioneries (which sold a variety of candies, baked items, canned goods and necessities) were common sights in German Village up until the 1960s. One address, 203 East Beck, housed a prime example.

The original brick structure is believed to have been built about 1900, with the framed portion being added later. By 1950, the addition, no more than 450 square feet, was housing Hartmann's Confectionery. A few years later, the Busy Bee took its place. Proprietors of both businesses rented the property from its owners and apparently lived in the original brick portion.

The Busy Bee carryout, at 203 East Beck, is seen in this vintage photograph. On the right is 583 South Fifth Street. *The German Village Society.*

Subsequent owners Donald and Mary DuRivage replaced the framed portion with a new one about 1990 and probably built the covered porch as well. The swimming pool, one of the smallest among a surprisingly large number of pools in the village, was added by owner Joe Parrish shortly after 2000.

228 East Beck Street
Frank Fetch Park

German Village's second city park (after Schiller) was once so ugly and despised that residents went out of their way to avoid it. Neighborhood resident Ann Lilly, who once lived nearby, recalls insisting on meeting out-of-town friends and relatives away from her Beck Street home because of her embarrassment over the run-down property.

NORTHEAST GERMAN VILLAGE

The future Frank Fetch Park in the early 1960s. The City of Columbus paid $6,000 for the fifth-of-an-acre lot, with plans to create a small park. *The German Village Society.*

The German Village Garten Club spearheaded a major renovation of Frank Fetch Park in 1996. Today, Garten Club volunteers help maintain the flowers and various plantings. *Author's collection.*

The park, which measures barely two-tenths of an acre, marks the location where two small houses once stood years earlier. About 1959, investors bought the vacant property with the hope of building apartments on it. This prompted German Village Society founder Frank Fetch to get involved. He persuaded the City of Columbus to buy the land and create a small "pocket" park. In return, the society agreed to help maintain it. Before long, Beck Square (or Beck Park, as it was also known in its early days) was beginning to look like a little biergarten. It boasted a brick patio, gaslights and picnic tables. Sometime later, the next phase began, with the installation of a pergola; fountains; a lush, grassy lawn; iron fencing (rescued from a home at South High and Gates Streets); and carefully chosen trees, plants and flowers. The park is even home to the first city-sanctioned beehive.

In 1985, the city agreed to change the name to Frank Fetch Park, in honor of the German Village Society's founder. Once known for an unfortunate amount of dog poop, this neighborhood gem now plays host to myriad community events, including summer concerts, outdoor movies and the annual lighting of the German Village Christmas Tree, as well as the occasional private wedding.

229 East Beck Street
Mathias Lang Home

The story of Lang Stone Company and the home at 229 East Beck Street almost belonged to Cincinnati history but for some pesky sandbars along the Ohio River.

The tale begins with the 1846 arrival in America of Mathias Lang, a German stonecutter whose family owned quarries near Wurttemberg in the old country (and who, history tells us, was trying to avoid military service in his homeland). In Pittsburgh, the young man met and married Petronella Trott, a widow with four children.

Soon, Lang made plans to move his new family to Cincinnati, which, like Columbus, boasted a large German population. But the riverboat on which he booked passage kept getting stuck on the Ohio River's many sandbars. By the time the boat eventually reached Portsmouth, Ohio, a frustrated Lang had changed his plans and decided to travel a shorter overland route to Columbus and settle there instead.

NORTHEAST GERMAN VILLAGE

The original home of stonecutter Mathias Lang, at 229 East Beck Street, prior to a major restoration in 1964. The small cottage peeking in from the right is believed to have been a schoolhouse. *The German Village Society*.

Lang and his wife bought a half acre of land on East Beck Street, across from what today is Frank Fetch Park. (See 228 East Beck Street.) In 1853, he proceeded to build the two-story, Federal-style farmhouse you see today. Originally, the stately brick home contained just four rooms—two down and two up. Before long, though, Lang built a rear addition, giving the home its current L shape. No doubt, the accomplished stonecutter fashioned all of the home's exterior steps, sills and lentils, as well as the decorative entrance posts.

The house remained in the Lang family until 1940. The next several years weren't so kind, with subsequent owners dividing it into low-rent apartments. The home's fortunes turned in 1964, when buyers Marion and Alice Boyer made improvements and restored the building for use as a single-family home.

In 2002, when the house changed hands again, the new owners also bought the small brick cottage on its west side and the story-and-a-half brick double on the east side. An extensive building project added more rooms to the rear of the properties. Today, 229 East Beck Street is the focal point of a larger property that includes three historic homes, plus a variety of additions, both old and new. (For more on Lang Stone Company, see 551 South Fifth Street and 205 Jackson Street.)

GERMAN VILLAGE STORIES BEHIND THE BRICKS

252 East Beck Street
The Industrial House

Until about 2002, visitors to the property at 252 East Beck Street wouldn't have had much to look at—just a standalone cinder block garage. But neighbors Brett and Andrea Cambern, who had only recently put the finishing touches on a new nearby home (see 184 East Beck Street), had much bigger plans for the lot, plans they sketched on a cocktail napkin while on vacation.

Architect William Hugus, who had worked with the Camberns before, was hired to flesh out those plans, adding details that would result in the construction of a 3,900-square-foot home. With its industrial elements, the house had its early critics. But while it bears little resemblance to the historic homes around it, the large residence, with its rear flat roof and multipaned metal windows, reflects a period in the first half of the twentieth century when small factories and other industries were common in the "Old South End."

Built by Brett and Andrea Cambern in 2002, 252 East Beck Street pays homage to a time when German Village was home to several small industries. *Author's collection.*

From rustic exposed finishes and structural elements to industrial-inspired lighting fixtures, the interior was designed to capture an era of manufacturing and mechanical ingenuity.

291 East Beck Street
The Hidden Treasure

Tucked away as it is, this sprawling, three-thousand-square-foot home is one of the most overlooked properties in German Village. Yet it was one of the neighborhood's first major renovations. The main portion of the house, on the east side (left side of accompanying photograph), was constructed in the 1870s. Over the next thirty years, two additions were built. But by 1973, when Bob Echele and Bob Gease undertook their renovation, the house had become an eyesore. Gease described it in even starker terms—as a "rat hole" and "slum tenement."

Number 291 East Beck Street, seen during the restoration and renovations of 1973. *The German Village Society.*

Undaunted, the business partners proceeded to add a master bedroom suite, along with a greenhouse, the patio, garden and private driveway. They also replaced all doors, windows and railings but were able to maintain the original slate roof over the main structure.

The house at 291 East Beck Street is one of five homes that Gease and Echele restored or renovated near the intersection of Beck and Jaeger Streets. They considered this a "warm-up" for future work on the village's famed Schwartz Castle. (See 492 South Third Street.)

328 East Beck Street
Hurryville

Every now and then, a person comes along who reminds the rest of us why we should even care about German Village. Frank Fetch was one of these people. Urban pioneer Dorothy Fischer was another. Both are mentioned elsewhere in this book.

Bob Hurry, a geophysicist from Texas, became a leading proponent of German Village restorations beginning in the early 1960s. *The German Village Society.*

NORTHEAST GERMAN VILLAGE

Another important name that should be remembered is that of Bob Hurry. Hurry was a Texas geophysicist who moved to German Village in 1961, just as preservation efforts were starting. Here, he fell in love with the neighborhood and began devoting all of his time to home restorations.

The first was his own, 328 East Beck Street—a dilapidated two-story brick Italianate that he bought for $3,000 in 1963. That may sound like a low sum, even for the early '60s, but Hurry once remarked that his part of the neighborhood was so bad that his friends refused to visit him after dark. In addition to 328 East Beck Street, Hurry was responsible for about a half-dozen full-scale restorations near the intersection of East Beck Street and Grant Avenue. He boasted that he never had to walk more than a block and a half to get to work. To this day, the intersection continues to be known by some residents as "Hurry's Corner" or "Hurryville."

Hurry inspired others with his steadfast devotion to historic buildings. He believed that no home built prior to 1900 should ever be torn down and that only a few built since then were beyond repair. Where a house was missing a foundation, he raised the building and added one. Where a house had an original slate roof, he made sure that any new addition would also have slate.

A dilapidated home at 328 East Beck Street, seen prior to Bob Hurry's restoration in the early 1960s. *The German Village Society.*

The same house, number 328 East Beck Street, shortly after restoration. *The German Village Society.*

And where he found dormers, he often removed them, returning rooflines to their original look.

From the '60s to the '80s, Hurry also guided others in their restoration work with "how to" articles in the German Village Society newsletter. He compiled the earliest guidelines for neighborhood preservation, and he wrote impassioned letters to newspaper editors, always promoting restoration over demolition.

It's appropriate to note that Bob Hurry was a gay man and that he and his partner felt comfortable enough in German Village—even in those early days—to live outside the shadows. This was at a time when most did not approve of their lifestyle, when many neighborhoods probably would have shunned the couple. But German Village has always been about inclusiveness. If you kept a nice home—or even better, if you restored one—most neighbors here did not care about your race, color, religion or sexual orientation.

Many gays flocked to the neighborhood in the 1960s, knowing they could find relatively cheap property and not be harassed. Today, we refer to Bob Hurry and other gays who were instrumental in the early restoration movement as "gay pioneers," and the German Village Society honors their

contributions. Bob Hurry was only fifty-four when he died of complications from AIDS in 1987, but his spirit lives on in the homes he restored and the example he set for the preservationists who followed him.

551 South Fifth Street
Lang Stone Yard

The curious, little cinder block building at 551 South Fifth Street has gone from stone company to art studio.

It was built in the early 1900s as a dispatch and retail office for Lang Stone Company, which was started by German immigrant Mathias Lang, shortly after his arrival here in 1846. The company built its warehouse and staging area next door. Lang wasn't the only stonecutter on the South Side, but the skills he brought from his homeland put him ahead of the pack.

The earliest limestone used by Lang was taken from the Marble Cliff Quarry Company in Upper Arlington. This was used to make the village's first foundations, water tables, fence posts and carriage steps. Other limestone was quarried in Reynoldsburg and in McDermott, Ohio, near Portsmouth. The McDermott stone was delivered to Columbus by barge. The softer sandstone, used for windowsills and lintels, came from southern Ohio.

Employees of Mathias Lang's stone yard are shown in this 1881 photograph at 551 South Fifth Street. *The German Village Society.*

Intricate carvings for the lintels, or "window caps," were traced onto the stone using tin templates. In the early days, lintels were sold for about five or six dollars each. Each stone fence post, like the ones in front of the Mathias Lang home at 229 East Beck Street, took about a day and a half to fashion and sold for about fifteen dollars. Curbstone for most of Columbus, by the way, was cut and shaped at Cleveland Quarries in Amherst, Ohio.

Since 1996, 551 South Fifth Street has been an art studio for German Village resident Sandy Kight. During the summer harvest, a weekly farmers' market is held on the gravel parking lot of this 432-square-foot building. (For more about Lang Stone and its founder, see the entries for 229 East Beck Street and 205 Jackson Street.)

By the way, want to know how to tell limestone from the softer sandstone? Only limestone will contain fossils. Look closely at any limestone steps or the "cheeks" on the sides of the steps and you're likely to spot the remains of numerous tiny prehistoric animals and, perhaps, the outlines of various ancient forms of vegetation

645 South Grant Avenue
Beck Place Condos

Over the past 125-plus years, the property bounded by Grant, Beck and Jaeger Streets has been occupied at various times by a warehouse, two or three commercial bakeries, a delivery station for the *Columbus Dispatch*, retail design firms the Doody Company and Retail Planning Associates (twice), the failed DrugEmporium.com pharmacy and the Columbus professional dance company BalletMet.

By 1889, German immigrants John and Sophia Lang (apparently no relation to the Langs of Lang Stone) were operating a small neighborhood bakery on this site. John was the baker in the family. But when he died just a few years later, Sophia took over the business and was soon joined by her three sons. The Lang family occupied one house next to the bakery and later bought a second one across the street.

The bakery remained in the family until about 1944, when the three Lang brothers sold the business to Ward Baking Company of Ohio. Almost immediately, the new owners leveled the existing buildings and built a much larger bakery, the remains of which can still be seen today.

NORTHEAST GERMAN VILLAGE

An undated photograph from the corner of East Beck Street and Grant Avenue shows the site of the future condominium complex as it looked while being used as a *Columbus Dispatch* warehouse. *The German Village Society.*

In 1980, the new offices of Doody and Company, shown here, won national awards in interior design. *The German Village Society.*

Today, a portion of the original seventy-year-old bakery building can still be seen in the new twenty-unit Beck Place Condominiums. *Author's collection.*

Plans for today's condominiums and town homes began in 2005, when new owners Taggart Management and Real Estate Services hired the architectural firm of Behal Sampson Dietz to design the modern housing units. A year later, following numerous discussions before the German Village Commission, a plan was approved. It was decided to save a historic portion of the building at the corner of East Beck and Jaeger Streets and incorporate it into the new design.

Work on the huge project stalled three years later but was eventually finished in 2009 by suburban homebuilder Donley Homes, Incorporated. Today, Beck Place consists of eight loft units in what remains of the old building, eight three-story town homes in a new section along South Grant Avenue and four units in a separate new building. All of the condos have attached garages that are accessible from a central courtyard.

The project was not without its critics. Some questioned the scope and size of the proposed condominium complex. But the neighborhood appears to have embraced the mix of old and new and even celebrated it, honoring two of the condos with inclusion in recent German Village Haus und Garten Tours.

NORTHEAST GERMAN VILLAGE

205 Jackson Street
The Warehouse House

One glance at 205 Jackson Street and you know this home is a little different. OK, a lot different. This unusual one-story French design started as the home of Lang Stone Company's cutting operation. This is where, about one hundred years ago, Lang employees cut and stored the company's raw materials, which were used in making German Village's early home foundations, water tables, sills, lintels, steps and carriage stones.

The building sat empty for a time after Lang Stone moved its operation to the Brewery District in 1959. In the 1970s, it housed the Alley Shop, an art gallery that specialized in framing posters and art prints. Then, in the '80s, the Columbus-based Weisheimer Companies, a pet food and supplies distributor, operated its warehouse here.

A major turning point for the old building came in 1996, when John and Sally McDonald bought it from the Lang family. With the help of architect John Behal of Behal Sampson Dietz, they began transforming it into the stunning three-thousand-square-foot home it is today. Oversized loading dock doors that once accommodated horse-drawn wagons were closed and fitted with windows and ironwork. Ceiling beams that once were used with hoists and pulleys to lift the stone were covered in wood. The brick façade was left largely intact.

This warehouse building at 205 Jackson Street was home to the Alley Shop art gallery in the late 1970s. *Courtesy of John and Sally McDonald.*

German Village Stories Behind the Bricks

This unique home, a former warehouse, has been featured in numerous publications and on national television. *Author's collection.*

The magnificent home and courtyard fill the entire 31- by 139-foot lot and then some, as the east side of the building extends 1 foot onto the city's paved right of way. Thankfully, no one seems to mind. (For more about Lang Stone Company and its founder, see 551 South Fifth Street and 229 East Beck Street.)

244 Lear Street
Foster Gear Company

Only three German Village streets have the same names today that they had in 1856, the height of German immigration: Kossuth, Third and Cedar Alley. Understandably, a community of German Americans who were new to the country preferred to name their streets after people and places with whom they were familiar—Schiller, Germania and Bismarck, to name just a few. However, with the arrival of World War I and some of the political theater that surrounded it, many names were changed.

The very first was Kaiser. Today, we know Kaiser as Lear Street. But for a few years, starting in 1918, it was Gear Street. Never heard of it? Very few have. It was "Gear" for the Foster Gear Company, a factory that made steering wheels for early automobiles—or "machines," as the residents here

NORTHEAST GERMAN VILLAGE

This drawing shows the sprawling Foster Gear Company, which was in operation along Lear and East Sycamore Streets from 1911 to 1917. *Columbus Metropolitan Library.*

An old Sycamore Street warehouse, now owned by Franklin Art Glass Studios, was one of the two main buildings of the Foster Gear Company. *The German Village Society.*

often called horseless carriages. The factory lasted only from 1911 to 1917, and very little else is known about it.

From the sketch, it appears to have been a substantial operation, though. The two smaller buildings are no longer with us. But the one in the middle of the illustration—the one with the two-story façade—is now a warehouse for Franklin Art Glass Studios. And the one on the left? Though it hasn't been confirmed, that one appears to be Franklin Art Glass Studios' main building. (See 222–224 East Sycamore Street.)

Like the company for which it was named, Gear Street didn't last long. The city changed it in 1932 to honor Oscar Lear, a Columbus auto pioneer. That, and too many people were getting "Gear" Street confused with "Geers" Avenue, located farther east.

548 Mohawk Street
Nature's Door

This small, cinder block building houses Nature's Door, described as a homeopathic medicine cabinet and health food store. It is believed to have been built in 1920, as Katherine M. Gochenbach's confectionery and ice cream shop. Later, in 1945, it served as an early location for Arthur H. Isaly's

Formerly a confectionery, cheese shop, dog grooming salon and business office, 548 Mohawk Street has long housed Nature's Door, a vitamin and natural remedies store. *Author's collection.*

cheese business. Since then, it has also served as a dog grooming salon and an office for Peerless Saw Company, which had its main operation on South Third Street. (See 571 South Third Street.)

Nature's Door measures barely three hundred square feet, making it one of the smallest retail stores in German Village.

South Sixth, Lear and Jaeger Streets
Franklin Plating

Preservationists agree that the area now known as German Village was primed for a long, downhill slide when, in 1923, the City of Columbus rezoned the South End from "residential" to "manufacturing and commercial use"—a change that would not be reversed until the 1960s. Sure enough, just one year later, a large metal plating and polishing company moved into an abandoned wholesale grocery garage at 274 Gear (now Lear) Street.

The old Franklin Plating and Polishing Company on Lear Street was leveled to make way for six new single-family homes. *The German Village Society.*

GERMAN VILLAGE STORIES BEHIND THE BRICKS

This small bungalow, which occupied the same lot as Franklin Plating and Polishing, was also demolished. *The German Village Society.*

Franklin Plating and Polishing brought with it a potential nightmare for environmentalists—untold amounts of copper, nickel, chrome, silver, zinc, cadmium, tin and silver. But the company thrived and eventually added more buildings to the site, including a small residential bungalow. In 1988, original owners the Charles Zang family sold the company, and the new owners reestablished it near East Fifth and Cleveland Avenues.

Within a short time, developers began arguing that the old buildings, including the bungalow, were built at a time when the neighborhood was deteriorating, and so they "did not reflect the once-thriving German residential community" and should come down.

Despite the controversy, the lot was leveled. Once the property was proclaimed safe from any possible chemical leftovers, six new two-story homes went up bounded by South Sixth Street on the west, Lear Street on the south and Jaeger Street on the east. Today, the issue over Franklin Plating and the new homes is hardly ever mentioned.

Part III
CENTRAL GERMAN VILLAGE

804 City Park Avenue
Mission Impossible?

In attempting to restore these old nineteenth-century homes, some projects prove to be almost impossible. Take the case of 804 City Park Avenue. In 1992, John and Susan Rosenberger bought the small frame cottage at this address.

A view of 804 City Park Avenue prior to its extensive restoration in 1992. *The German Village Society.*

The 804 City Park Avenue address today, with the rebuilt frame cottage and the new two-story brick addition. *Author's collection.*

Their plan was to move the home slightly forward, toward City Park, and build a brick addition at the rear. But they hadn't counted on the little house being in such poor condition.

For starters, it had no real foundation, just a few rocks sitting on bare ground. Over the years, the walls had partially rotted. And the floor joists, whose ends had come to rest directly on the soil, were badly deteriorated. Moving the little house intact was no longer an option.

Still, striving to save what they could of the old cottage, the Rosenbergers had the south, west and north walls stored in a warehouse until they completed work on the brick addition. The walls were then moved back to the lot, close to their original location, and were used in reproducing the original cottage. Today, the original house has a new foundation and roof and serves as a living room.

828 City Park Avenue
The Bijou

For close to sixty years, the narrow, three-story building at 828 City Park Avenue served as a studio and home for acclaimed artist Edmund Kuehn

CENTRAL GERMAN VILLAGE

and his wife, Liese. Liese tells of once using the first-floor space as a dance studio before Edmund's paintings took up residence there. But this old commercial and residential building, with its original cast-iron façade, had an interesting history almost a half century before the Kuehns bought it in 1952.

From 1911 to 1927, the first floor was home to the Bijou, a neighborhood nickelodeon theater showing all the popular short films of the day—scintillating titles that may have included *Coroner's Mistake*, *Anarchist's Mother-in-Law* and *Indian Basket Weavers*. For five cents, patrons got the opportunity to view one or more of the ten- to fifteen-minute shorts of the day. No doubt, Mondays were very popular. It has been recorded that on those days, instead of paying a nickel, you could gain entrance with a potato. Yes, a potato.

The large, three-story building at 828 City Park Avenue, complete with its original iron façade, continues to serve as a private home. *Author's collection.*

You might be surprised to learn how many nickelodeons and movie theaters the German Village area has had over the years. In addition to the one at 828 City Park Avenue, a nickelodeon operated for a time in the east end of today's Book Loft (see 631 South Third Street). Gary Helf, who owns Franklin Art Glass Studios, remembers hearing of a theater called the Sycamore, which was located in his Sycamore Street parking lot about 1915. Later, when "talkies" came along, the Thurmania on the northeast corner of Thurman Avenue and Jaeger Street was quite popular. Old-timers remember it operating from roughly 1930 to about

A close-up of the iron façade at 828 City Park Avenue shows that it was manufactured by P. Hayden & Sons of Columbus, Ohio. *Author's collection.*

1945. The comparatively large Columbia Theater was at 281 East Whittier, an address most recently associated with the 4S Club. And then there was the Victory Theater, in the 200 block of Livingston Avenue. Add in the numerous movie houses on nearby South High Street and on Parsons Avenue and you had plenty of choices for a Saturday afternoon matinee, all within walking distance.

729 SOUTH FIFTH STREET
Bierberg Bakery

For all her days in America, German-born Theresa Bierberg loved to tell of the time she once made a cake for the Kaiser. She had no idea that she herself would someday be remembered for starting something her friends in this country would also find pretty special. Today, we know Theresa Bierberg as the woman who began a ninety-nine-year tradition of baking and selling German Christmas cookies.

Ferdinand Bierberg, a tailor and also a German by birth, met Theresa Hoehl in Columbus, where they were married in 1910. When Ferdinand fell ill in 1913, Theresa began baking out of her kitchen on South Eighteenth Street, marketing her goods to some of the area's wealthier families. Though she also made tortes and fancy cakes, this marked the beginning of the long Bierberg Christmas cookie tradition.

CENTRAL GERMAN VILLAGE

The iron-and-wood façade of the former Bierberg Bakery at 729 South Fifth Street. *Author's collection.*

Eventually, their success forced the Bierbergs to move to a larger location, with son Gus and his wife taking an ever-more-active role in the family business. In 1971, following Theresa's death, Gus and his German-born wife, Emma, moved their family and the business to German Village.

The couple chose a piece of property on South Fifth Street with two buildings: a small frame house (725–727) and a second frame house next door (729), which had been built as a blacksmith's shop in 1882. Here, for the next forty-plus years, the Bierbergs, including subsequent generations, delighted folks every Christmas season with Theresa's famous recipes: petit fours, marzipan, lemon-flavored sugar cookies, pinwheels and vanilla sticks, along with another Old World favorite, stollen, the traditional German fruit cake.

Bierberg Bakery was open only for the Christmas season, selling an estimated two to three tons of baked goodness each year. And so it was, until 2013 and the sad news that the little bakery, after ninety-nine years, had "retired." The pressures of family, school and full-time jobs were to blame; however, another Bierberg, this one from the fifth generation of bakers, says she would like nothing better than to see the old ovens fired up again.

710–712 Jaeger Street
Martin Carpet Cleaning

The Martin family was stumped. Their ancestors had started the well-known Martin Carpet Cleaning company in 1890, somewhere in German Village. Of that, they were certain. But the exact location had been lost to time. They knew what the building looked like from an advertisement in an 1894 *Columbus City Directory*. And from that same ad, they had an address: "710 and 712 Siegel St., Cor. Sycamore."

The problem is that the city of Columbus has never had a "Siegel" Street or anything with a similar name. Family members thought the company might have been near South Sixth and Sycamore Streets, and sure enough, old maps confirmed that the B.F. Martin family owned five acres in that general area. But the buildings at the corner of South Sixth and Sycamore Streets appeared to have been built too early to have followed Martin Carpet.

F. MARTIN'S STEAM CARPET CLEANING WORKS,
710 and 712 Siegel St., Cor. Sycamore. Telephone 1255.

Dry Cleaning and Perfect Renovating of FINE CARPETS, RUGS, ETC.
We refer by permission to The Krauss, Butler & Benham Co., 72 and 74 North High Street, and to David C. Meehan "Ruggery," 49 South High Street, Neil House Block. WHERE ORDERS MAY BE LEFT.

This ad, from the 1894 *Columbus City Directory*, places Martin Carpet Cleaning at the corner of Siegel and Sycamore Streets. There was no such official address. *Columbus Metropolitan Library.*

At times like this, one must not underestimate the resourcefulness and patience of the staff at the Franklin County Engineer's Office. After one phone call, they were on the case, combing through and comparing myriad late nineteenth-century county maps. Within two days, the mystery was solved.

Though the action was never official—or legal—a small portion of Jaeger Street was once known as "Sigal" Street. The name existed only as a label on a map, though; no name change ordinance was ever passed. How it became so well known as to be included in printed advertising is anyone's guess. So, 710–712 Siegel Street turns out to be the present-day 710–712 Jaeger Street, specifically on the northeast corner of Jaeger Street and Alexander Alley, a few steps south of Sycamore Street. Today, you'll find condominiums on the site and absolutely no trace of the previous building.

An interesting side note about Martin Carpet Cleaning: After moving from German Village in 1895, the family established themselves at the west end of the Town Street Bridge, near COSI. In 1913, the building fell victim to the catastrophic flood that killed hundreds of Columbus residents and

Maps indicate this was the location of the first Martin Carpet Cleaning location: 710–712 Jaeger. Today, it's home to condominiums. *Author's collection.*

damaged or destroyed thousands of buildings. The next stop for the company was an abandoned cigar factory in the Brewery District, and finally, in 1955, they settled into their current home at 795 South Wall Street. Case closed.

43 East Kossuth Street

German Village Outhouses

There's no shortage of euphemisms for one of the most important assets an early German Village family could own: the privy, the crapper, the buffy or, how about this one, used during Ohio's frigid winters, the crystal palace.

After 1929, perhaps the most common nickname for an outhouse was the Chic (pronounced "chick") Sale. Unless you're an expert in vaudeville-era stand-up comedians, you may be scratching your head over that last one.

Chic Sale was the stage name of humorist Charles Partlow (1885–1936), whose tongue-in-cheek routine on outhouse construction was made into a

CENTRAL GERMAN VILLAGE

Once a common sight in the village, outhouses may number fewer than a dozen today. *The German Village Society.*

bestselling book in 1929. It sold more than one million copies. Eventually, the name of the man who wrote about outhouses became synonymous with outhouses themselves. (Reportedly, he didn't care much for the association. Go figure.)

Whatever you called it, everyone had one. And in the German Village area, a few were still in use as late as the 1960s. Typically, as running water and sewer pipes gradually made their way to the South End, city employees would run individual lines to the homes and remove the outhouses. But a few of them—perhaps a dozen—remain. Many are similar to the one in the backyard of John Saunders and Julie Bango, at 43 East Kossuth Street. Restored to its original look, complete with slate roof, this outhouse today serves as a gardening and toolshed.

But the Kossuth Street privy does have one unusual feature. It's a double, with a door on each end and a privacy wall in the middle. Originally,

GERMAN VILLAGE STORIES BEHIND THE BRICKS

The "double" outhouse at 43 East Kossuth Street has been preserved as a toolshed. *Author's collection.*

this property and the one to the immediate east were owned by the same family. When the lot was split in the 1920s, the line was run right through the outhouse. Each homeowner retained one-half ownership. And that arrangement exists to this day.

An interesting fact about the neighborhood's outhouses: They moved around a lot. No, not on their own, of course. But as the pit beneath one filled, there was no means of emptying it. So the homeowner just topped off the old hole with dirt, dug another one a few feet away and dragged the outhouse over to it.

And one final note about South Side sanitation: It's no secret that in the past few years, there have been some concerns about the structural integrity of our more than one-hundred-year-old sewer lines. What you might not know is that these kinds of problems didn't just recently occur. A news report from June 1870 drew attention to the collapse of a four-hundred-foot section of sewer line along South Fourth Street. Repair costs were projected to run as high as $500.

150 East Kossuth Street
Helen Winnemore's

In November 1937, a Quaker Sunday school teacher couldn't help but notice her small students wiggling around in their adult-sized chairs, their feet constantly swinging above the floor. She decided to fix that and, in doing so, set upon a course that would lead her to open one of the nation's foremost contemporary arts and crafts shops.

Her name was Helen Winnemore. After earning a college degree in Iowa, she enrolled in the fine arts program at the Ohio State University. While in college here, she also taught Sunday school at a nearby Friends meetinghouse. To search for child-sized chairs, Winnemore and a church committee traveled to Berea College in eastern Kentucky. Berea has long been known for its many excellent arts and crafts shops. Winnemore found the smaller chairs she had been looking for and more.

It was November, and Berea College leaders asked Winnemore if she would be willing to sell some student-made Christmas crafts on consignment back in Columbus. She was intrigued. And she had an empty room in her Grandview home. The deal was made. Winnemore quickly set up an "afternoon shop" in

GERMAN VILLAGE STORIES BEHIND THE BRICKS

Helen Winnemore, a former Ohio State art student who in 1937 started the American arts and crafts store that still bears her name. *Sarah Kellenberger.*

her living room, which attracted the attention of neighbors and friends. The little business caught on. More artists approached Winnemore about selling their items, and before long, she was renting actual retail space at East Broad Street and Parsons Avenue on the city's near east side.

From the beginning, Helen Winnemore's was a different kind of store. The vast majority of the towels, bedspreads, handwoven textiles and jewelry she stocked were handmade by American artists she knew personally. Every

CENTRAL GERMAN VILLAGE

Since 1966, this converted doctor's office has been the home of Helen Winnemore's, a shop that sells fine American-made crafts. *Author's collection.*

customer who walked in was offered a cup of tea or coffee. (Winnemore claimed she was shy and that the offer was an easy icebreaker.) Because of space limitations in her home, she began putting jewelry and other small items for sale in dresser drawers. Shoppers were invited to open the drawers and look through the merchandise.

By 1966, Winnemore was ready to move again, this time to a more "family like" setting. She chose the former home and office of Dr. Raymond Langins at the northwest corner of Mohawk and Kossuth Streets in the recently designated German Village Historic District. Business only got better.

Winnemore's philosophy was simple: Encourage people to buy handcrafted items over those that were mass produced. And make every customer feel at home. She was quoted as saying, "No shop is worth anything unless it is a gracious shop."

After Winnemore's retirement, the store passed to her longtime friend and store manager, Jack Barrow. Winnemore died in 1996 at the age of ninety-five. In 1997, Barrow himself was ready to retire and didn't have to look far to find the perfect buyer: twenty-eight-year-old Sarah Kellenberger.

Kellenberger had been a devotee of Helen Winnemore's since she was a little girl, shopping there with her mother and grandmother. And she was thrilled by the opportunity to continue in Winnemore's and Barrow's footsteps. She shares the founder's feelings about handmade crafts and how a business owner should treat customers. Visit Helen Winnemore's today,

and you'll still be offered coffee or tea. And the drawers are still there, too—more than forty of them now, carefully stocked by Kellenberger and her staff to delight the treasure hunter in anyone who steps through the door.

240 East Kossuth Street
Schmidt's Sausage Haus

It's argued that no one can claim to be a true German Villager until he or she has been asked for directions to Schmidt's. The famed German restaurant has been packed with adoring patrons, including thousands of German Village visitors, almost daily since opening its doors in 1967. But the Schmidt's story actually began more than eighty years earlier, before there was even a thought of a restaurant, when recent German immigrant J. Fred Schmidt opened a small meat packinghouse and shop on the south side of Kossuth Street between Purdy Alley and Jaeger Street.

It wasn't long before Columbus residents were clamoring for Schmidt's special-recipe sausages, and the small three-story business (including the second-floor home) grew to true factory-sized proportions. Packinghouse employees slaughtered and processed thousands of hogs over the years, including the occasional "escapee," which often had to be returned to incarceration by neighborhood boys.

In the 1960s, just as preservation work was taking hold in South Columbus, the city decided to ban the slaughter of animals within its limits. The Schmidt family, now headed by grandson George F. Schmidt, had a difficult decision to make. They could close the family business, move it outside Columbus or transition into a fully retail operation. Schmidt's sausages had been wildly popular at the Ohio State Fair since the family first opened a food stand there in 1914. The Schmidts also owned the old Weilbacher Transfer Company building. Weilbacher was a nineteenth-century moving service that used horses and wagons. That building was just around the corner from the packing plant. If they handled this right, the Schmidts could continue to thrive as restaurateurs. And thrive they have.

Company president Geoff Schmidt, the founder's great-grandson, says timing was everything. As more and more people heard about German Village and came to visit the restored area, many wanted to dine in authentic German surroundings. The new Schmidt's Sausage Haus afforded that

CENTRAL GERMAN VILLAGE

Schmidt's Packing Company was torn down in 1967 and replaced by the Schmidthof, a twenty-four-unit town house apartment complex. *The German Village Society.*

Shmidt's Packing Company employees at work, probably in the 1890s. Schmidt's employed a number of women, as well, mostly on the processing lines. *The German Village Society.*

GERMAN VILLAGE STORIES BEHIND THE BRICKS

Above: Schmidt's Sausage Haus opened in 1967 in the former home of the Weilbacher Transfer Company, a moving company that used horses and wagons. *The German Village Society.*

Left: A mural from the original packing company offices hangs in Schmidt's Sausage Haus. A friend of founder J. Fred Schmidt's often painted on the walls. *Author's collection.*

opportunity. Such is the continuing popularity of Schmidt's, with its trademarked Bahama Mama spicy sausages and giant cream puffs, that it has been featured on at least four television networks and in countless publications. It has also been visited by many celebrities, including Whoopi Goldberg, Arnold Schwarzenegger, Senator John McCain and others.

Fifth-generation Schmidts now help run the family business, one that shows no signs of slowing down. A magazine writer recently referred to the restaurant as "the beating heart of German Village." Based on its popularity, defined in part by the average wait time for a seat at dinner, few villagers would argue.

791 Lazelle Street
Capital Soda Water Company

The two-story brick building at 791 Lazelle Street has served a dizzying number of needs over the past century and a quarter.

An old ad, presumably from a newspaper or the *Columbus City Directory*, touts the cleanliness of the soda water factory on Lazelle Street. *Columbus Metropolitan Library.*

Originally intended as a stable or garage, 791 Lazelle Street serves today as a modern 3,500-square-foot home. *Author's collection.*

Opposite, bottom: The addition to 639 Mohawk Street was designed in a way to make it appear as a separate house. *Author's collection.*

Historians believe it was built as either a stable or a garage. By 1910, the Capital Soda Water Company operated a small factory here, bottling mineral water and ginger ale. Perhaps the owners could sense the coming Prohibition era, starting in 1920, and wanted to capitalize on it by selling nonalcoholic beverages. Alcohol sales—including beer sales—were illegal in the United States until the repeal of Prohibition in 1933, the same year the Capital Soda Water Company closed its doors.

Over the years, 791 Lazelle Street is believed to have been an iron foundry, a fertilizer factory, a business that made ceramic kilns and a factory that produced water filters and water pumps.

Then, in the 1980s, came Steve Shellabarger, who believed "you can take almost any space and make it livable." He had done that already to a former Kroger grocery store at 365 East Beck Street. This cavernous, thirty- by fifty-five-foot building posed unique challenges. So he and his partner decided to embrace the industrial feeling that came naturally to it and worked those elements into the design of the home. The result was a spacious, airy and quite comfortable three-thousand-square-foot home with an attached two-car garage. And it has remained a home ever since.

CENTRAL GERMAN VILLAGE

639 MOHAWK STREET
Special Addition

Of the 1,700 or so buildings in German Village, all but a handful have been enlarged over the years, but few quite as cleverly as 639 Mohawk Street. Built in 1867, the original brick cottage occupied an unusually large lot. More

Built in 1867, 639 Mohawk Street was a small cottage on an unusually large lot. *The German Village Society.*

than one hundred years later, suburban homebuilders the Truberry Group paid $300,000 for the run-down property and began a truly innovative expansion. The group built what appeared to be a separate two-story brick home a few yards to the south of the original one and connected the two structures at the rear.

To the casual observer, the rear connector is practically invisible, giving the appearance of two separate homes. At the time, Truberry owner Scott Shively commented on the unusual project, saying it was like restoring one home and building a second one at the same time

673 Mohawk Street
St. Mary's High School

What happens when a magnificent old building is no longer suited for its intended purpose? In the case of the old St. Mary's High School, a lot. Built by the Catholic Church in 1887, the three-story brick building with Gothic-style elements started life as an elementary school. It was expanded in 1896 and then began housing all grades. In the 1950s, St. Mary's Elementary School moved to a new home on South Third Street, leaving the old building for the exclusive use of high school students. St. Mary's High School then closed with the graduation of the class of 1968.

That closing set in motion a debate over what to do with the empty building. Neighbors clashed over a plan to turn it into an office and commercial complex. The German Village Society and Commission voiced their disapproval of the plans, and opponents collected four hundred signatures on a petition against the redevelopment. (For the story of St. Mary's first high school, see 664 South Third Street.)

Over these objections, though, plans went forward in the early 1970s, and the old school was sold and readapted for commercial use in 1973. As part of the renovation, the building received recycled brass doors on the south side from Columbus's old Bliss Hotel. A spear-point wrought-iron fence in front came from the Powell Mansion. And the site was further adorned with eighteenth-century French lampposts.

Dollar Savings was the first of several banks to open on the site in 1974. In an effort to project a German appearance, bank officials had their female tellers wear dirndls. The space continued to house bank branches

Built as an elementary school in 1887, St. Mary's eventually transitioned into a high school, graduating its last class of students in 1968. *The German Village Society.*

until 2013. A much more radical plan for adaptive use came about then, when Cardinal Health founder Robert Walter and his wife, Peggy, bought the school building with plans to turn it into a 13,500-square-foot private residence, the second-largest in Columbus. Again, reactions were mixed. But as of this writing in early 2015, plans are moving forward to create one of the grandest historic homes in Central Ohio.

766 Mohawk Street
Hand-Dug Basement

These days, John McGown gets all the credit for having been awarded the land we now call German Village. But the southernmost area of the historic district, roughly south of Sycamore Street, first belonged to another Canadian refugee, Jonathan Eddy. We don't hear as much about Eddy because he never even visited his new property. While McGown moved into South Columbus with his family and made a name for himself in the

community, Eddy chose to sell his 320 acres, sight unseen. He apparently lived the rest of his life in the Northeast.

Early on, the property we know as 766 Mohawk Street, originally belonging to Eddy, was sold and resold until it reached the hands of German immigrants Alois and Catherine Ebner in 1871. Ebner is listed in city directories as a chair maker in the 1870s. Later, he worked as a clerk at Zettler's Grocery, just a couple blocks away.

Catherine couldn't read or write and spent most of her time raising the couple's four children. But she also displayed the industriousness and strong work ethic for which the early Germans were known. Therefore, the fact that she singlehandedly dug the home's basement, using only a horse and a scoop, may not be too surprising.

When he died in 1903, Alois left his wife the household furniture and any money left over after his debts were paid. She was also given use of the house

Catherine Ebner and children in front of their home, date unknown. The box around the tree was to keep horses from nibbling at it. *The German Village Society.*

and property for as long as she remained unmarried. Catherine lived as a widow for the next thirty-three years and died in 1936.

A note about basements like the one Catherine Ebner dug: These structures were vital to early South Side residents. Basements were used to store home-canned vegetables, sauerkraut and homemade wine. And while most homes here apparently had summer kitchens—small lean-to additions in the rear of the houses—it wasn't unusual to cook meals, and even eat them, in the small dirt-floor basement. This was especially true in summer, when high temperatures made the regular kitchen unbearable.

819–821 Mohawk Street
The Old Mohawk

Few buildings in German Village have had as many rumors associated with them as 819–821 Mohawk Street. If all of them are to be believed, Al Capone visited here during Prohibition looking for a source for southern Ohio moonshine; the second floor housed a brothel for so-called pavement princesses; and it remains the home of the ghost of Gene "Coach" Slaughter, a Capital University football coach who co-owned the Old Mohawk and frequented the bar until his death in 1998. All are untrue.

The facts about the address are almost as interesting as the myths. Though the origins of the building are unclear, we know it held a speakeasy and dry goods store in the 1920s. Later, a drugstore operated in the south half of the building. In 1933, the year Prohibition was repealed, Myles Elk from Chillicothe opened Elk's Tavern in the north half of the building, and it quickly expanded to occupy the entire first floor. The horseshoe bar you see here today was installed at that time.

Weighing in at five hundred pounds, Elk was known as the "biggest attraction" in the neighborhood. And he presided over day-to-day operations from a specially reinforced chair. During this time, the tavern became known for two menu items in particular: turtle soup and fried snapping turtle. Neighborhood children are said to have supplied the turtles, which Elk is rumored to have kept in his dirt-floor basement. The floor was continually sprayed with water to keep the turtles wet, and it was his children's job to clean them for cooking.

GERMAN VILLAGE STORIES BEHIND THE BRICKS

Myles Elk, who tipped the scales at five hundred pounds, was the proprietor of Elk's Tavern and the man who put fresh turtle soup on the menu. *The Old Mohawk.*

Known today as the Old Mohawk, 819–821 Mohawk Street has been serving food and drink to the neighborhood since 1933. *Author's collection.*

Myles Elk passed away in 1945. His family, along with new help, continued running the establishment until 1972 but under a new name: Mohawk Grill. The restaurant and bar then changed ownership a couple of times before being renamed Tiffany's in 1975. In 1977, it sold once more and took a modified version of its previous name.

Today, the Old Mohawk continues to operate as a popular neighborhood eatery. Turtles are no longer raised in the basement. But look closely, and you'll see that they have found their way into the restaurant's logo.

222 East Sycamore Street
Franklin Art Glass Studios

When Dave Thomas calls up and orders forty-five thousand stained-glass lampshades for his Wendy's restaurants, you'd better know what you're doing. That's basically what happened in the mid-1960s. Lucky for Dave, he picked Franklin Art Glass Studios. Owner James Helf, whose grandfather Henry had been a foreman for the famed glass artists the von Gerichten brothers, was up for the challenge.

In the 1920s, Henry Helf was working at the von Gerichten Art Glass Studios in Columbus and passing his love for the craft on to his son, Elmore. Elmore and two business partners started Franklin Art Glass in 1924, with Elmore eventually assuming sole ownership. When the von Gerichten brothers parted ways in 1931, Elmore was positioned to buy much of the old company's equipment.

For years, the staff of twenty to twenty-five artisans was kept busy making specialty stained-glass windows for churches, businesses and private homes in central Ohio and across much of the eastern United States. Then came the call. Ramping up for a large long-term project like the one for Wendy's meant doubling the staff and moving into more spacious quarters. In 1966, the Helf family found exactly what they needed at 222 East Sycamore Street, in a building that had housed a commercial chemical laboratory in the 1950s, a United States armory in the '20s and quite possibly a steering wheel factory before that (see 244 East Lear Street).

Over the next several years, more calls would come in—from Max & Erma's, White Castle, Victoria's Secret and others. In addition to custom work performed for businesses and homes, creating large windows for

GERMAN VILLAGE STORIES BEHIND THE BRICKS

Henry Helf and co-workers at the von Gerichten Art Glass Studios, probably in the 1920s. Helf is on the far right. *Gary Helf.*

The home of the renowned Franklin Art Glass Studios is on East Sycamore Street. The company makes stained-glass windows for a wide variety of customers. *Author's collection.*

An employee of Franklin Art Glass Studios puts the finishing touches on a custom stained-glass window. *Author's collection.*

churches and synagogues was still a huge part of the company's business. But increasingly, the Helf family was catering to hobbyists as well, selling glass and supplies to walk-in customers and over the Internet and offering on-site classes.

After James, three subsequent generations of Helfs have entered the family business. So, more than 125 years after the von Gerichtens began making their highly prized windows, South Columbus continues to be home to nationwide leaders in stained-glass designs and installations. (For more about the von Gerichten brothers and their art glass studios, see 117 East Deshler Avenue.)

650 SOUTH THIRD STREET
Cheese and Ice Cream

Now recognized as the German Village Starbucks, 650 South Third Street has had interesting histories both as a pharmacy and a cheese and ice cream shop.

In 1975, a ninety-two-year-old Detroit man wrote to his nieces about his early years growing up in the South End. He remembered going with friends

into Klein's Drug Store in the evenings and ordering sundaes. "Mr. Klein would take a large glass, place it in a metal holder with two large dips of ice cream, add crushed fennel or flavor, the price—five cents."

Others have recalled attending Third Street German-English Elementary School next door (see 630 South Third Street) and not being able to drink the sulfur water from the school's well. Several would cross the street after class and ask Mr. Klein for a glass of his tap water. They said he would give them their water, usually with a scowl on his face. But if you also bought a penny's worth of candy, he would break into a smile.

The drugstore eventually closed, and in 1961, a famous dairy company moved in. The Isaly family was already well known to Ohioans, having moved from their native Switzerland to Mansfield in 1833. There, they established the Isaly Dairy Company and began opening retail stores from which to sell their signature cheeses. From one small shop sprang more than six hundred others, spread across five states. By then, their ice cream offerings were just as popular as the cheese.

Henry R. Isaly came to Columbus in 1899 and opened a cheese shop in the city's Central Market downtown. When the market closed in the late 1950s, grandson Bob moved it to South Third and Sycamore Streets, where it would serve customers for the next fifty-plus years, alongside other smaller

Henry Isaly's grandson Bob moved the family's Central Market cheese shop to 650 South Third Street about 1958. *The German Village Society.*

Isaly's shops sprinkled throughout the neighborhood. Two of the company's ice cream treats in particular kept customers coming back for more. One was the "skyscraper" cone, twice as tall as a regular cone, and the other was another Isaly invention—the Klondike Bar, which is still manufactured by the Good Humor-Breyers company.

A changing business climate led to the sale of Isaly's dairy operations beginning in the 1960s, and the cheese and ice cream shops began closing, as well. But the South Third Street shop that bore the Isaly's name got a reboot in 1995, when business partners Kathy Conway and Joyce Flanigan bought the business, redecorated and expanded the store's offerings to include deli sandwiches and beer. Five years later, they lost their lease on the building, Starbucks moved in, and one of the last remaining Isaly's stores closed its doors.

Today, only three shops operate under the Isaly's name, all in Pennsylvania. But it will be hard to forget that name because of an early advertising phrase—**I** **S**hall **A**lways **L**ove **Y**ou **S**weetheart—an old message from the owner to his wife.

664 SOUTH THIRD STREET
The Other High School

If you've been around German Village for any length of time, you're probably familiar with the old St. Mary's High School on Mohawk Street—the one that's being converted into a private home (see 673 Mohawk Street). But what about the old, old high school, the one at 664 South Third Street? Remember that one?

One of Columbus's most respected citizens in the mid-1800s was a judge named Henry Olnhausen. He and his family lived in a beautiful two-story brick home with covered porches and black shutters at 664 South Third Street on the north side of St. Mary's Church. It was often referred to as the "Olnhausen Homestead." The date of construction is not known, but the family vacated the house prior to the start of World War I. St. Mary's Church congregation bought it, stripped it of its porches and shutters and began using it for classroom space.

The little high school opened for business in 1914 and also took over part of the elementary school building on Mohawk Street. A member of the state board of education later remarked, "There is a little high school down on

Above: The Henry Olnhausen family in front of their home at 664 South Third Street in 1890. The house would later become St. Mary's first high school. *Max & Erma's Restaurant.*

Left: The new Berkley Center addition is shown next to St. Mary's Church in this 2015 photograph. It sits on the site of the former Olnhausen home. *Author's collection.*

South Third Street, called St. Mary's. It's in an old fashioned building, but let me tell you, it's the best high school in the state. "

The old Olnhausen house continued in use until 1960, when it was torn down to make room for a convent. Today, the site is occupied by the renovated Berkley Center. (For more on the St. Mary's High School that closed in 1968, see 673 Mohawk Street.)

739 South Third Street
Max & Erma's Restaurant

Today, 739 South Third Street is known as the birthplace of Max & Erma's, the popular restaurant chain that grew to one hundred locations. But its rich history dates back much further.

It's believed that a local brewery constructed the three-story building in 1889 and put Tobias Lamprecht in charge of running the first-floor saloon and grocery. Lamprecht and his family lived on the second floor, and the third was a fest hall, where parties were held and singing societies would perform for the public.

Small villages in rural Germany often had town plazas where these events were held. When the early German immigrants settled in this country's urban centers, like Columbus, they transitioned to halls. Halls were once scattered all around the Old South End.

The Lamprechts began receiving help from their niece, Annie Kaiser, and she took over the saloon when they died. Under Annie, the bar also began serving food. It was the kind of place where you could bring in a bucket and have Annie fill it up with her mother's chicken noodle soup—a dime a bucket, no matter how big the bucket. Men would often send their sons to Annie's in the evenings to pick up a bucket of suds for them. It was just that kind of place.

During Prohibition, Annie's was converted into a grocery store. But as soon as Prohibition ended, Annie was back to selling soup and beer. When she retired from the business, Annie was followed by a succession of short-term owners until 1958. That's when a beer truck driver named Max Visocnik and his new wife, Erma, an American Legion Post bar manager, decided to enter the bar business on their own and bought the old saloon. Both were good-natured and hardworking, taking only Sundays off and living on the second floor. Business was good.

GERMAN VILLAGE STORIES BEHIND THE BRICKS

The original Max & Erma's Restaurant at 739 South Third Street. *The German Village Society.*

CENTRAL GERMAN VILLAGE

One day in 1972, two men walked into the bar and told Max they wanted to buy him out. At first, Max thought they were kidding. But they returned a few days later, asking again about buying the bar. Max spoke briefly with his wife, and they decided that, after fourteen years of filling beer glasses, retirement sounded pretty good. Todd Barnum and Barry Zacks paid Max his asking price, and the deal was sealed.

With Max and Erma's permission, Barnum and Zacks began opening family-friendly restaurants bearing their names and likenesses. The now retired Visocniks moved to a comfortable house in Grove City, where, sadly, Erma died just four years later. But Max was still going strong, visiting all the restaurants that bore his and his wife's names and always wearing a T-shirt that read, "The Original." And the new managers of the German Village Max & Erma's kept a seat open for him at the bar, where he had been promised free beer for the rest of his life. Max passed away in 1995.

Max and Erma Visocnik pose for the camera shortly after their marriage. *Max & Erma's Restaurant.*

As for the business that still bears their names, Max & Erma's had some lean times, leading up to a 2009 bankruptcy reorganization, and was forced to sell several locations. Since then, a new company has taken over and moved the chain's corporate offices above the original South Third Street restaurant. Business appears to be on the upswing again. No doubt, Max and Erma would be proud.

769 South Third Street
Hausfrau Haven

Unfortunately, little is known about the earliest days of 769 South Third Street. In the only photograph known to have survived from that period, probably from about 1890, we see that it housed a "sample room," a saloon and a grocery or hardware store—the one with the display of handmade brooms in front. The second floor, from which you can see a woman leaning out a window, apparently has always been apartments.

In the 1950s, a portion of the first floor housed Adam Sauer's grocery. A few years later, Tony Shumick, who had owned his own grocery on South Fifth Street, moved to larger facilities here. Tony specialized in fresh meat, which was delivered to the side of the building, hung from hooks on a track suspended from the ceiling and pushed along to the walk-in cooler on the other side. Longtime villager Russ Arledge remembers that as a boy, he and his friends would grab onto the hooks when Shumick wasn't looking and take joy rides through the store.

In the mid-1970s, partners Fred Holdridge and Howard Burns bought the building and opened their own small market, which they called Hausfrau Haven. From the beginning, Fred and Howard (always identified by their two first names, with Fred's first) projected a unique, eclectic style of doing business. When two or more customers began asking for the same thing, they stocked it. Wine and the *New York Times* Sunday paper were especially popular items. They closed one day a year—January 1—when neighbors and customers would pitch in and help them take inventory. And they weren't shy with their sharp wit. Signs on the front door proclaimed, "Unattended children will be sold!" and "We will not be taken over by The Limited!"

CENTRAL GERMAN VILLAGE

The large commercial and residential building at 769 South Third Street as it appeared shortly after construction, probably about 1890. *The German Village Society.*

In the mid-1970s, building owners Fred Holdridge (left) and Howard Burns (right) opened the eclectic Hausfrau Haven. *The German Village Society.*

Eventually, Fred began taking on more and more neighborhood civic duties, especially with the German Village Society, and Howard and his mother became the faces behind the counter. Hausfrau Haven was still going strong twenty-five years after opening its doors when Howard died in 2001. Five years later, Fred sold the store, with the agreement that he could continue living above it until his death. He passed away in 2010.

Today, the new owners continue running Hausfrau Haven in much the same way it was run for the previous quarter century. In 2014, the German Village Society dedicated a plaque honoring the achievements and contributions of Fred and Howard. It can be seen today, attached to the southeast corner of the building.

860 South Third Street
Wirtz Brothers Bakery

Some of the very best memories of the Old South End seem to have involved bakeries. Stories recorded in old newsletters go on and on about the wonderful smell and the excitement of children when their parents sent them for a coffee cake or stollen, a sweetened German bread with nuts and raisins.

One of the most popular of the local bakeshops was Wirtz Brothers on the southeast corner of South Third and Lansing Streets. Wirtz Brothers was founded in the very early years of the twentieth century by brothers Fred, Joseph and Andrew. And all three lived nearby at 76 East Kossuth Street.

Writing back in 1978, villager Helen Stiner recalled being sent to Wirtz Brothers to get a crispy, round loaf of bread for dinner and "waiting patiently to see if there was enough change coming to buy a big, crispy, raised-dough pretzel, sprinkled with rock salt." She said that's all she and her siblings needed to get them back home. Wirtz Brothers was famous for its big soft pretzels, which it sold to saloons all over the city.

No one seems to know how long the business lasted. Interestingly, old fire maps show 860 South Third Street to be an empty lot by 1914. And it may have remained vacant until about 1954, when a small office building went up on the site.

Descendants of the Wirtz family have continued living in German Village. Mary Louise Hendricks, who was well known in the neighborhood,

CENTRAL GERMAN VILLAGE

Mary Wirtz (Green) is shown in front of the family business in this photograph, believed to have been taken between 1900 and 1910. *The German Village Society.*

Today, an office building sits on the former site of Wirtz Brothers Bakery at 860 South Third Street. *The German Village Society.*

was a second-generation member. And Mary Wirtz Green, shown in the accompanying photograph, was the grandmother of current villager Jerry Esselstein. By coincidence, Jerry lives on South Third Street directly across from the site of the former bakery.

PART IV
SOUTH GERMAN VILLAGE

967 City Park Avenue
Stewart Avenue Elementary

On a hot July night in 2010, a 48-year-old man broke into Stewart Avenue Alternative Elementary School and, under the influence of alcohol, set fire to the 135-year-old building. Firefighters were able to extinguish the blaze before it could destroy the historic school. Still, damage was estimated at $1 million. Columbus City Schools opened the former Beck Elementary to Stewart students and teachers while school leaders decided what to do next.

The original eight-room school opened in 1875 as the New Street School. But the name didn't stick for long. It changed three times after New Street became City Park Avenue. The school board finally settled on the current name in 1894. The eight classrooms filled quickly as the neighborhood grew, and the school was enlarged in 1894 and again in 1926.

The school system had considered closing Stewart in 2002 as part of a $1 billion "facilities improvement plan." Perhaps officials underestimated the value German Village places on its historic buildings and how hard the neighborhood would fight to save its beloved Stewart Elementary. So when arson struck, instead of proposing again to dismantle the school, the school system offered up more than $11 million for renovations and a third expansion.

GERMAN VILLAGE STORIES BEHIND THE BRICKS

Stewart Avenue Elementary after additions were made in 1894 and again in 1926. *The German Village Society.*

Students and teachers at Stewart Avenue Elementary pose for their class picture in the 1920s. *The German Village Society.*

After three years in a borrowed building, Stewart Avenue students and faculty returned home in January 2015 to a much larger and more modernized facility. An elevator, air conditioning, Wi-Fi and interactive classroom "smart boards" were just a few of the many improvements.

SOUTH GERMAN VILLAGE

The new Pearl Street entrance to Stewart Avenue Elementary, in early 2015, following extensive renovations and expansion. *Author's collection.*

Perhaps most important, though, is a policy change that will allow German Village parents to send their children to Stewart without having to worry about winning a school lottery, as they did before.

1000 City Park Avenue
The Caretaker's Cottage

This small Tudor-style home was built in the mid-1930s as part of President Franklin Roosevelt's Works Progress Administration, later known as the Work Projects Administration. The WPA was one of the federal government's New Deal programs, designed to give work to the unemployed. Long known as the "Caretaker's Cottage," it replaced a larger park superintendent's home that had occupied the site since 1820.

The original home first belonged to Francis Stewart, who, at the time, owned land known as "Stewart's Grove." It was from this grove that the 23.5-acre Schiller Park (first City Park, then Schiller Park, later Washington Park and then Schiller once again) was created in 1867, making it Columbus's second-oldest city park behind Goodale.

GERMAN VILLAGE STORIES BEHIND THE BRICKS

The Schiller Park Caretaker's Cottage, built by the Works Progress Administration in 1935. *The German Village Society.*

The east side of the original park superintendent's home, which had belonged to landowner Francis Stewart. The house faced north (right in photograph), toward Reinhard. *The German Village Society.*

SOUTH GERMAN VILLAGE

Like the cottage that replaced it, the original superintendent's house sat just inside the west entrance to Schiller Park along City Park Avenue. But where the Caretaker's Cottage faces west, toward City Park Avenue, the original home faced north, in the direction of Reinhard Avenue.

For years, the current Caretaker's Cottage housed park employees and other tenants. Today, the City of Columbus leases the Caretaker's Cottage to the Actor's Theatre of Columbus, which performs free Shakespeare plays each summer in the Schiller Park Amphitheater.

1023 City Park Avenue
A Civil War Coincidence

Typical of the larger homes facing Schiller Park, 1023 City Park Avenue was constructed in 1883 for John Saile and passed through at least three generations of the Saile family. More recent owners of the brick Italianate added to the rear of the home and turned it into a bed-and-breakfast.

As coincidence would have it, Saile served in the Union army, just as Johann Adam Fornof of nearby 67 East Deshler Avenue had done. And like Fornof, Saile had even spent time in the notorious Andersonville Prison Camp, in Andersonville, Georgia.

For his part in the war, Johann Adam Fornof volunteered for duty even before gaining his U.S. citizenship and fought in many of the war's most famous campaigns. His luck ran out on July 22, 1864, when he was captured by Southern troops during the Battle of Atlanta. After just two months at Andersonville, Fornof made a break for it, walked in circles

The home of John Saile at 1023 City Park Avenue. Shown here are his wife and two children, date unknown. The German Village Society.

139

in the woods for a few days and eventually met up with his old unit. It's not known whether Fornof and Saile ever served in the same regiment or whether they even knew each other during the war.

After serving for a few years as a bed-and-breakfast, 1023 City Park Avenue has been restored to its original purpose, as a magnificent, single-family home.

117 East Deshler Avenue and 181 Thurman Avenue

The Von Gerichten Brothers

Few would argue that 117 East Deshler Avenue, itself a stunning century-old Queen Anne–style home, has the most beautiful door in all of German Village. The large inset stained-glass panel from the acclaimed Von Gerichten Art Glass Studios in Columbus belonged to none other than Theodore von Gerichten.

Theodore was born in the Rhine Valley in 1863. His brother, Ludwig, came along ten years later and, by the age of eight, was displaying a keen interest in art. By 1887, the two brothers and their father, a nurseryman by trade, had moved to the United States and were living in a large

The stunning stained-glass door at 117 East Deshler Avenue was designed by an artist in the von Gerichten brothers' glass studios. *Author's collection.*

SOUTH GERMAN VILLAGE

A 2015 view of 117 East Deshler, the former home of Theodore von Gerichten. *Author's collection.*

German settlement just north of Birmingham, Alabama. Theodore sold insurance for a time while Ludwig headed off to Cincinnati to become a stained-glass apprentice.

The brothers operated an art glass company in Alabama for a while but soon decided to move their operation to Columbus, Ohio. They lived for a while on Kossuth Street and then above their first studio on the west side of South High Street near East Beck Street.

Ludwig, the artist, eventually took up residence in the stately two-story brick home at 181 Thurman Avenue. In 1909, Theodore, the bookkeeper, moved into this elaborate brick Italianate on East Deshler Avenue, embellishing it with examples of his designers' finest work.

GERMAN VILLAGE STORIES BEHIND THE BRICKS

The former home of Ludwig von Gerichten, 181 Thurman Avenue. *Author's collection.*

Ludwig von Gerichten, who, with brother Theodore, opened the von Gerichten Art Glass Studios in Columbus, Ohio. *German Village Society.*

Ludwig and Theodore continued to prosper, bringing additional artists to Columbus from Germany and eventually opening a second studio in Munich. Some customers preferred to have their windows made in Germany, thinking the quality would be better. The truth is that they were virtually indistinguishable from the Columbus windows. Between roughly 1900 and 1930, the Von Gerichten Art Glass Studios produced almost two thousand windows for churches around the world, not to mention an untold number of windows for individuals.

In 1904, the von Gerichten studio won four gold medals and top honors at the St. Louis World's Fair. And in 1906, Ludwig helped found what would become the Stained Glass Association of America. The brothers had made Columbus a nationwide center for art glass. But tragedy was looming. Ludwig's wife, Katherine, died in 1913. Two years later, Ludwig von Gerichten Jr., known as Buddy, died following an episode of class hazing at the New Mexico Military Institute in Roswell. Theodore's son, who was being groomed to take over the business, also died young.

With the Great Depression came a greatly reduced demand for stained glass. And in 1931, the brothers severed business ties over a dispute that has never been fully explained. Theodore continued running the old company for a few more years, and Ludwig opened a new one on Mount Vernon Avenue. Theodore died in 1938. Ludwig passed away seven years later while fishing from the pier at his country home on Buckeye Lake.

A von Gerichten stained-glass window in Trinity Lutheran Church at 404 South Third Street. *The German Village Society.*

However, that wasn't the end of stained glassmaking in Columbus. Elmore Helf, whose father, Henry, was a shop foreman for the von Gerichtens, started his own stained-glass company in 1924. With the help of his father, he later acquired most of the equipment and tools from the von Gerichten firm for his new business, Franklin Art Glass Studios (see 222 East Sycamore Street), which remains successful to this day.

Meanwhile, the stunning glass door at 117 East Deshler Avenue serves as a beautiful reminder of the immense talent the von Gerichten brothers brought to Columbus more than one hundred years ago.

133 East Deshler Avenue
A Winning Restoration

This magnificent American Foursquare Victorian has seen many changes over its lifetime. Built in 1908 as a single-family home, it later housed a doctor (whose office was the small frame house behind it, along South Fourth Street), was converted into a boardinghouse during the neighborhood's downturn and turned back to a single-family home in the 1980s. It was the recipient of a full restoration in 2006.

William and Joseph Bott, who started what is now known as the Elevator Brewing Company, built the home about 1908. Immediately, it was recognized as a showplace and was featured in numerous newspapers.

In 2006, new owners were preparing a full restoration of the property when they were aided by a stroke of luck: the chance discovery of the original house plans.

Today, the home features two master suites on the second floor, a second-floor balcony and a third master suite on the third floor. Custom cabinets and appliances in the new kitchen were "floated" to preserve the exquisite woodwork on the walls surrounding them. Rare, quarter-sawn red oak floors and nine-foot-tall pocket doors were restored, and modern uses were found for many other original design elements, whose removal were made necessary by the change in floor plans.

Attention was also given to the intricate front porch floor tiles, similar to those still in use at Elevator Brewing Company; the gas-burning pole light in front of the house; and even the original stone carriage step at the curb. Two sets of original leaded-glass front doors continue to frame the home's vestibule.

The stately home at 133 East Deshler Avenue is one of many along the southern edge of Schiller Park. This stretch was once referred to as "Dutch (Deutsch) Broadway." *Author's collection.*

The hard work and attention to detail earned the homeowners a 2008 Preservation Award from the German Village Commission. The preservation award is given to property owners in recognition of an "outstanding example of restoration, preservation, or maintenance of a property or architectural element in German Village."

147 East Deshler Avenue
The "Arm Strong" System

One of German Village's oldest two-story Victorians also has one of its most interesting histories. Built about 1884 by master stonemason Friedrich Wittenmeier, this stately three-story home on Schiller Park was not as ornate as many of its predecessors, but it was just as magnificent on the inside, with two living rooms, twelve-foot ceilings, sculpted Italian marble fireplace mantels and running water.

Yes, in 1884, this home was among the first in the village to feature running water—in both an upstairs bathroom and a downstairs lavatory. However, getting the water through the pipes was something of a chore for the family's

GERMAN VILLAGE STORIES BEHIND THE BRICKS

Left: The home at 147 East Deshler Avenue is seen during its years of decline, probably in the 1960s or '70s. *The German Village Society.*

Below: The same home, 147 East Deshler Avenue, as seen today. *Author's collection.*

four boys, who had to hand-pump it from the basement to a holding tank on the third floor. It was called the "arm strong" system. When the boys were not in school—and not pumping water—they, along with their four sisters, could often be found on that same third floor playing on their swings and custom-installed roller rink.

Wittenmeier lost his home in 1913 in a failed business venture to sell stone for the construction of the statehouse annex. Over the years, the house slid into decline. In 1962, owners divided it into apartments. Then, in the early 1990s, new purchasers restored the home to single-family use and built onto the rear. A new two-car "tandem" garage was placed where the old chicken coops and grape arbors had been. Since then, the property has become more beautiful with each subsequent owner.

100 Reinhard Avenue

The Beer Tent Corner

What's an Oktoberfest without beer? It was a question the German Village Society faced in the mid-1960s. The plan was to raise money for neighborhood causes by hosting an annual Oktoberfest in Schiller Park. It seemed like a natural fit for the old German neighborhood.

But there was one little snag. The City of Columbus, which owns and maintains Schiller Park, wasn't about to bend its rule against alcoholic beverages in its parks. And most people agreed that it wouldn't be much of a festival without beer.

Enter Ray and Eleanor Noltemeyer. Back in 1957, Ray had bought a large corner lot at South Third Street and Reinhard Avenue with plans to eventually build the couple's dream home on it. The sellers were the Baumann family, whose immigrant patriarch Ferdinand Baumann, a contractor, had operated a lumber mill on the site at the turn of the century. With a view of Schiller Park directly across the street, it was a prime location.

Turns out, it was an ideal spot for a beer tent, too. Oktoberfest was saved. For the next few years, Schmidt's sold beer to Oktoberfest fans on the Noltemeyers' private vacant lot. Visitors were allowed to drink on the corner, as well as on a portion of Reinhard Avenue, which had been temporarily closed to traffic. They just couldn't take it into the park.

GERMAN VILLAGE STORIES BEHIND THE BRICKS

The lumberyard of German immigrant Ferdinand Baumann on the northeast corner of South Third and Reinhard Streets. The photograph was taken about 1900. *The German Village Society.*

SOUTH GERMAN VILLAGE

The corner of South Third Street and Reinhard Avenue today, with the home Eleanor and her husband, Ray, built in 1993. *Author's collection.*

Opposite, bottom: Eleanor and Ray Noltemeyer (center) with daughter Diane Carrick and grandchildren, shown during the 1967 Oktoberfest on the site of their future home. *The German Village Society.*

After just a few years, Oktoberfest outgrew the Schiller Park location and moved to the state fairgrounds, where the beer flowed freely. And in 1993, Ray and Eleanor built their dream home right where the beer tent had been just a few years earlier.

79 Thurman Avenue
The Watch Factory

More than a century ago, German Village was a center for the manufacture of pocket watches. Long before timepieces were small enough to strap to your wrist, the pocket watch was a marvel of micro-engineering with hundreds of tiny precision-made parts, all stuffed into a metal case not much bigger than a silver dollar.

In the 1870s, German-born Dietrich Gruen operated small watch-making shops along High Street in Downtown Columbus. In 1882, he consolidated

GERMAN VILLAGE STORIES BEHIND THE BRICKS

The Columbus Watch Company at 79 Thurman Avenue, seen here about 1889. The surviving two-story building in front is now an office building. *Columbus Metropolitan Library.*

Watch factory employees take advantage of sunlight from the building's many windows in this 1890 photograph. *Columbus Metropolitan Library.*

his operations by building a modern factory at 79 Thurman Avenue. He called his new business the Columbus Watch Company.

The main building's many windows helped workers see the tiny mechanisms better while a steam engine at the back of the property provided power for the factory's machinery through a complicated system of pulleys. With his business partner, W.J. Savage, Gruen employed a small army of workers to turn out up to 150 pocket watches a day—first with Swiss-made movements and then with their own. The craftsmanship was excellent, and the watches are highly sought after today as collectors' items.

Unfortunately, the company didn't last long. In 1892, Gruen and Savage lost a patent infringement case that went all the way to the U.S. Supreme Court. Then, during the Panic of 1893, shareholders forced Gruen out of the company he had built. After this, the business was reincorporated as the New Columbus Watch Company. But the bad luck continued. In 1899, two executives were shot during a holdup just outside the company's offices. Three years after that, another new set of owners moved the business and some employees out of state. Since then, the Thurman Avenue property has been used for a variety of purposes, including shoe manufacturing and the home of plumbing and electric supply firms. As of 2015, the original 1882 building houses a dentistry firm and other offices.

121 Thurman Avenue
Engine House No. 5

Old Engine House No. 5 was a landmark in the days of horse-drawn fire wagons. Built about 1892, the Romanesque-style firehouse served Columbus's Old South End until 1968, at times housing firemen and horses alike.

In 1973, Michigan restaurateur Chuck Muer bought the building and, following a $1 million renovation, added Engine House No. 5 to his growing list of seafood restaurants. The restaurant and its basement bar, "The Spot," remained popular Columbus nightspots for twenty years. Hardly an evening went by that a host or hostess was not seen sliding down the original fire pole to deliver a birthday cake to one table or another.

Then, tragedy struck. In March 1993, Chuck Muer and his wife were sailing from the Bahamas to Florida when a storm apparently capsized

GERMAN VILLAGE STORIES BEHIND THE BRICKS

Firefighters from Engine House No. 5 pose with the station's horses and firefighting equipment in this photograph from the 1890s. *Columbus Metropolitan Library.*

In 1980, Engine House No. 5 was named a "German Village Historical Site." Restaurant owner Chuck Muer is in white. The plaque has since disappeared. *The German Village Society.*

their forty-foot boat, *Charley's Crab*. Except for a brief distress call, the Muers—lost in the infamous Bermuda Triangle—were never heard from again. For a while, the couple's seven children continued to run the family business. Eventually, however, they sold much of their restaurant holdings, including Engine House No. 5, to the Landry Seafood restaurant chain in Houston.

Not long after the sale, Landry's decided to close Engine House No. 5. Employees showed up for work on a Sunday afternoon only to learn of the restaurant's fate—and theirs—from a small sign taped to the main entrance.

After sitting vacant for a few years, the building would next be used as the corporate headquarters for Big Red Rooster, a retail branding and architecture firm. The new owners stripped away paneling and carpet to reveal the original walls and slate floors. They kept the fire pole, too. And every once in a while, a lucky client or two can be seen sliding down it, just like in the old days.

263 East Whittier Street
Barcelona Restaurant & Bar

Over the years, many German Village restaurants have proved so popular that they've had to expand into neighboring spaces. Lindey's, Old Mohawk, Max & Erma's, Katzinger's and Brown Bag are just a few. Another was Deibel's, the wonderful old German restaurant and saloon on East Whittier Street, where latter-day crowds were entertained by a four-foot-eight-inch accordion player named Esther Craw.

In 1895, the Brunswick Company, known at the time mostly for its sporting equipment, began building a small corner tavern at 259 East Whittier Street, in what is now the hostess area of Barcelona Restaurant & Bar. It also built the solid oak back bar, which is still used today.

Shortly after the saloon opened in 1897, Hoster's Brewing Company bought it and hired Bill Deibel as its tavern keeper. It was a job he would keep until he died, more than forty years later. Being at the end of the streetcar line, Deibel's became quite popular. It's also believed to have served as a ticket office for professional "base ball" games and Ohio State University football games, which were played across the street at Recreation Park 2 (see 280 East Whittier Street).

Deibel's Bierstube at 263 East Whittier Street before it expanded into the Parkview Pharmacy space next door. *The German Village Society.*

Roughly ten years later, a small recreation center went up next door, and Deibel began managing it, too. It was the kind of place where you could buy a beer and get a free game of bowling at one of the two lanes in the back or shoot billiards at the front of the bar while contemplating a haircut in the establishment's lone barber chair.

Years later, when Prohibition went into effect, Deibel leased the recreation center out as a Piggly Wiggly "self-serve" grocery. At the same time, a nearby baker was able to buy out the original bar from under Deibel, and the baker's daughter opened Parkview Pharmacy. When Prohibition was repealed, the Piggly Wiggly reverted to a fully functioning Deibel's Restaurant & Bar, and the baker's daughter continued running the pharmacy.

After Bill Deibel died, the place apparently went through a succession of owners and became rather run-down. It was saved in 1964, when two men who had been ski resort builders took over and began making the place presentable again. Phil Henry and Bob Lumpe began a tradition of showing silent films with piano accompaniment in the back. They also opened the restaurant's first biergarten.

SOUTH GERMAN VILLAGE

Henry and Lumpe installed Deibel's first biergarten in the mid-1960s. *Courtesy of Scott Heimlich.*

The diminutive Esther Craw, once called the "accordion with legs," entertained Deibel's patrons for years at 263 East Whittier Street. *The German Village Society.*

155

Barcelona Restaurant & Bar, seen here in 2015, moved into the former Deibel's location in 1996. *Author's collection.*

Five years later, Tom Silcott bought the place. He's the one who hired the diminutive Esther Craw, a former USO entertainer who had toured with Bob Hope, to entertain patrons with her accordion. Esther was a huge hit and continued playing at Deibel's for years.

Then, in 1981, Silcott was presented with the opportunity to buy the original bar—the one that had become a pharmacy. He jumped at the opportunity and quickly joined the two buildings to form one big Deibel's. Deibel's would see other new owners over the years until 1996, when it closed for good.

Later that year, Kyle Katz stepped in as the building's next owner. He overhauled the entire restaurant and reopened it as the upscale Barcelona Restaurant & Bar. Six years later, he sold to Scott Heimlich, and Barcelona has been going strong ever since. It's consistently rated among the top fine-dining restaurants in Columbus. And the little biergarten out back has grown to become the most popular patio in town.

Part V

OUTSIDE THE HISTORIC DISTRICT

387 East Beck Street
The Poorhouse

Many of us baby boomers grew up hearing our parents exclaim, "You're driving us to the poorhouse!" If we had lived in German Village in the mid-nineteenth century, Mom and Dad would not have had far to go. Simply turn south from Livingston Avenue onto Lathrop Street, and you would have run right into the Franklin County Poorhouse, where Beck Elementary School stands today. In fact, maps from the mid-nineteenth century denote today's Lathrop Street as "Poor House Street" or "Poor House Lane."

Renamed the slightly less depressing "Franklin County Infirmary" in 1850, the county's second poorhouse was a taxpayer-supported institution that housed up to 260 poor and disabled residents, mostly the elderly. Poorhouses were common throughout the United States prior to 1935 and the passage of the Social Security Act, which shifted much of the responsibility for the indigent from counties to the federal government.

The main poorhouse building and several associated structures sat on an eleven-acre tract from Beck Street on the north to Sycamore Street on the south between Briggs and South Ninth Streets. Built in 1840, it was just outside the present-day German Village Historic District.

GERMAN VILLAGE STORIES BEHIND THE BRICKS

A rare sketch depicting the main building of the second Franklin County Poorhouse on Beck Street. *Columbus Metropolitan Library.*

In 1867, the Ohio legislature called for the creation of a State Board of Charities to monitor conditions at publicly supported jails and infirmaries. The first report on the county infirmary came a year later. It showed the residents to consist of "80 infirm and indigent persons, 53 insane and idiotic people and 30 orphans under care." The so-called insane were housed on the upper floor of a smaller separate two-story building. While conditions for the general population were only hinted at, they must have been far better than those for the insane, "for whom any conceivable change of horrors would be a relief," the report stated.

On the afternoon of June 27, 1878, fire broke out in the kitchen of the main building, quickly spread to the roof and forced the county to find temporary lodging for most of the 260 "inmates." Many went to nearby homes. Though repairs were made, it was clear that a new facility was needed. In 1882, the Franklin County Commission authorized the purchase of ninety-eight acres of land along what is now Alum Creek Drive. And on November 6, 1883, residents were moved to the larger and more modern county infirmary, a facility that would be used for the next eighty-five years.

For a while, there were efforts to use the main poorhouse building as a school. However, workers had significantly weakened the structure while

Beck School was built on the site of the poorhouse in the late 1800s. The school is shown here in 2015. *Author's collection.*

carving out classroom space, and it soon became apparent that it had to go. Within about a year, Beck Street School was being built to replace the main structure, with the rest of the property being divided into residential lots.

Though the horrors of the old institution have long faded from memory, little reminders still pop up from time to time. While excavating school grounds in April 1966, workers discovered huge shackle chains, the kind once used to restrain people. At least one of the surrounding houses is said to have been built on part of the old institution's foundation; cells with bars are said to be visible in the basement. And yes, at least two houses built on former infirmary property are said to be haunted.

41 West Columbus Street
The Corncrib

One of the South Side's most interesting home restorations actually occurred just outside the area that would become the German Village Historic District at

The tiny home at 41 West Columbus Street as seen shortly after its renovation in 1948. *The German Village Society.*

41 West Columbus Street. When Dr. William Heintz, a physician and Franklin County coroner, bought the building in 1920, it was a simple, slat-sided corncrib at the Hoster Brewery on Front Street. Heintz, who needed a place to store his new Marathon touring car, moved the tiny structure to its current location on West Columbus, added barn siding and converted it into a garage.

In 1948, city employee Frank Fetch and his father-in-law, Harry Royse, saw the building as an opportunity to promote home restorations in Columbus's much-neglected "Old South End." They paid Heintz's son $450 for the tiny building and lot; reclosed the end of the structure; added a small kitchen, loft bedroom and fireplace; and ended up with the first of their four early restorations. In fact, Fetch and his wife, Elnora, liked the little place so much that they decided to move in for a while. The unique home, still just 350 square feet, has remained occupied to this day.

It's ironic that, in a period when the city was declaring many of our South Side homes "unfit for habitation," Fetch was taking an old corncrib and making it not just suitable but also desirable

Incidentally, the little corncrib had a famous occupant at one time—Dick McCutcheon, a marine who was the very first grand prizewinner on the old *$64,000 Question* TV game show.

OUTSIDE THE HISTORIC DISTRICT

550 SOUTH HIGH STREET
South High Street Car Barn

With all the talk in recent years about bringing light rail to Downtown Columbus, it may be surprising to know the city once had a thriving rail system—even back to the days when "horse power" meant just what it said.

The first rail cars, pulled by horses, debuted along High Street in 1863. Their top speed was only five or six miles an hour, but it still beat walking. By 1888, electricity was coming into vogue, and in just a few short years, electric streetcars had put the horses out to pasture.

Maintenance and storage of the streetcars, both horse-powered and electric, required the construction of several "car barns" throughout the city. Today, two of these historic buildings are still standing at the edge of German Village. The one at 555 City Park Avenue—just inside the historic district—likely was built in the 1890s, just as the use of horses was being phased out (see 555 City Park Avenue). Today, rail historians believe it was used primarily for storing track maintenance equipment, such as snow sweepers.

The facility now known by its 550 South High Street address—just a block outside the historic district—was of more importance. By 1873, a wooden car barn on North High Street was falling apart. Streetcar company officials decided to relocate it along South High Street at East Beck Street. Using many of the materials from the old barn, workers constructed a two-story building in a large depression at the southern end of the lot. This allowed horses to pull their cars up a slightly inclined ramp from High Street for a distance of forty feet to a second-floor entrance. Once inside and unhitched, the horses were led down a second, internal ramp to their stalls.

A small house was also built on the property for the use of rail employees, and a second one was planned. Another building housed a blacksmith shop, and a smaller building, toward the back of the property, was used to store feathers. Yes, feathers.

Maps show that by 1887, this structure—or possibly a replacement—had been extended west, right up to the edge of High Street. By 1901, the house and smaller buildings were gone (presumably along with the feathers), and the car barn covered the entire lot. By 1921, maps showed today's configuration, with a brick car barn occupying the northern third of the property and the southern two-thirds empty. As trolley cars were being phased out in favor of trolley buses, which did not require track, company officials decided to retire the old barns, as well.

GERMAN VILLAGE STORIES BEHIND THE BRICKS

The view looking north along South High Street as police officers guard the South High Street car barn (on the right) during the violent 1910 streetcar workers' strike. *The Galen Gonser Collection.*

Rear of 550 South High Street, date unknown. After horsecars were phased out, horses continued to be used to help maintain overhead streetcar wires. *Courtesy of Angela Petro.*

OUTSIDE THE HISTORIC DISTRICT

The old South High Street car barn at 550 South High Street doubles as an event space and catering kitchen. *Author's collection.*

Over the years, the large brick building would house a brake service, a tractor sales company, two businesses that sold dictating machines and at least two restaurants and bars.

In 2011, 550 South High Street got its first new owner and first major renovation in decades. Angela Petro, a German Village resident who already owned the successful Two Caterers catering business, remade the old car barn into an upscale event rental space called the High Line Car House. A new mezzanine houses catering offices. Cooking is done in a large kitchen at the rear of the building. And on the main floor, just above the old tracks, up to 350 guests can dance, dine and drink the night away. Having stood for more than one hundred years, as horsecars and streetcars faded into distant memories, this magnificent old building is serving us once again.

Incidentally, South Columbus once had a near-famous streetcar employee. Born in Vinton County, Ohio, the gentleman, known as Frank, moved here in the late 1890s, when he was barely twenty years old. He quickly found work as a streetcar motorman, the person who actually drove the cars. Whittier Street is believed to have been one of his more frequent runs. But this was before the motorman's platform was enclosed, and the harsh Columbus winters quickly took their toll on him. After a year or two of frostbitten fingers, Frank decided he'd be better

Among early South Side streetcar motormen was Francis "Frank" Nixon, father of President Richard Nixon. He's on the right in this photograph, taken about 1900. *The Donald A. Kaiser Collection.*

off in sunny Southern California. There, he married a girl from Indiana, and together they raised five boys, one of whom would grow up to be President Richard M. Nixon.

966–976 South High Street
Columbus Maennerchor

When the majority of Germans immigrated to Columbus and other midwestern states in the mid-nineteenth century, they brought with them an abiding love of the cultural arts. They quickly organized singing societies, drama clubs, gymnastics organizations, shooting clubs and more. The Germania Singing and Sports Society, founded in 1866, survives to this day at 543 South Front Street in the former home of brewmeister Nicholas Schlee. At one time, the South End was home to up to thirty singing clubs of all sizes.

The granddaddy of all German arts organizations in this region, however, had to be Columbus Maennerchor. Established in 1848, Columbus

OUTSIDE THE HISTORIC DISTRICT

This former church parsonage at 966 South High Street served as Columbus Maennerchor's home for about ninety years. It sits just one block west of the German Village Historic District. *The German Village Society.*

Maennerchor is regarded as the oldest and largest continuously operating German singing society in North America. Legend has it that at the club's first practice, the original twelve members, short of funds, shared six candles by which to read their music. Maennerchor's stated purpose was *Gemuetlichkeit*—providing a warm and friendly atmosphere for the local German American population.

Columbus Maennerchor boasted three thousand members at the height of its popularity, following World War II, as Americans of German descent sought to reconnect with their European roots. The addition of women's and children's choirs contributed to the rise in membership. Beginning in 1921, the organization made its home in a former church parsonage at 966 South High Street, expanding the old home time and again to meet its growing needs. By the early 2000s, however, it became apparent that a dwindling number of members (down to about three hundred) could no longer afford the huge property, and the club began looking for ways to downsize.

A solution came by way of an unfortunate fire and the growing needs of Columbus City Schools. In the summer of 2010, an arsonist damaged

Columbus Maennerchor was the most famous South Side singing society, but it was far from alone. This quartet, known as the German Song Birds, was one of twenty-nine others. *The German Village Society.*

large portions of the adjacent Stewart Alternative Elementary School (see 967 City Park Avenue). The board of education, which had already planned to renovate the building, took the opportunity to expand it, as well. The school board paid Columbus Maennerchor $1.3 million for the 966 South High Street address, including a parking lot, for expansion of the elementary school. The singing society retained a house it had been

OUTSIDE THE HISTORIC DISTRICT

using for storage at 976 South High Street and turned that building into its new headquarters.

Today, Columbus Maennerchor members say they are poised for a "new beginning." The push to recruit new members has already begun in the hope of keeping the country's oldest German singing society going strong for decades to come.

346 East Stewart Avenue
Grosses Bakery

On October 15, 1882, a young German baker by the name of Albert Gross landed in America and began making his way west to the South Side of Columbus. For a while, he made a living by hauling barrels in a wheelbarrow. The pay was only five dollars a week, but it was enough for him to get married, start a family and, in 1890, start his own business.

For the site of his home and bakery, Gross chose a wide-open area just east of Schiller Park, known then as the commons. The address, 346 Germania Street, was soon changed to 346 East Stewart Avenue, the address we know it by today. And life, as you no doubt can guess, was difficult.

Having watched the gentrification of their old neighborhood firsthand, Lillian Gross McDowell and sister Lucille Gross Cook told their story in an early edition of the German Village Society's newsletter. The two sisters were among seven girls

Grosses Bakery was built in the 1880s in a large, open "commons" area on East Stewart Street, just outside German Village. *The German Village Society.*

and one boy born to Albert and his wife. The family sold groceries, bread and cakes from their building's first-floor retail area and lived on the two upper floors. Much of the actual baking took place in a separate building in the back, near the horse stable and the carriage shed.

A typical workday for those who were old enough to help was 5:00 a.m. to 5:00 p.m., six days a week. The only water to be had came from a pump outside. There was no gas for cooking, no electricity and no telephone. Heat

The old Grosses Bakery building exists to this day as apartments. *Author's collection.*

was provided by a fireplace and, perhaps, a wood- or coal-burning stove. Need air conditioning? Sure, just open a window.

If you opened a front window, there wouldn't have been much to look at—very few houses and an unpaved and often muddy street. Sidewalks were but a dream, and so were streetlights. On anything other than a full moon night, you would need to take your oil lamp with you. You have to wonder how they made ends meet, considering the money they brought in. A typical sale would be a three-cent loaf of bread.

But the Grosses did make it, just like hundreds of other families living here at the same time. They prospered, as did their children and their children's children. We are fortunate, today, to have had families like the Grosses who laid the groundwork for the thriving neighborhood we now enjoy. And we're thankful to residents like Lillian and Lucille, who help us preserve these old memories for generations to come.

767 South Wall Street
A Frank Fetch Restoration

This is the little house that started a big movement.

By 1959, Columbus city employee Frank Fetch and his father-in-law, Harry Royse, had bought and restored two small South End homes and were earning rental income from both. (See 41 West Columbus Street for the story of one of them.) Next, they set their sights on this one-and-a-half-story, German-built brick cottage at 767 Wall Street, just two blocks from the present-day historic district.

Putting any effort at all into these old buildings seemed silly to many, especially at a time when three city-funded studies had recently recommended total clearance and redevelopment of the area. The northern third of the old German neighborhood was already falling victim to the wrecking ball in the name of urban renewal and a new section of interstate highway.

But the Fetches and a few friends and acquaintances were determined to show that the old neighborhood still had a lot going for it. Fetch and his wife, Elnora, had spent many summers touring restored historic villages across the country. As he said years later, "Restoration wasn't such an unusual topic as far as we were concerned."

GERMAN VILLAGE STORIES BEHIND THE BRICKS

Frank Fetch and his father-in-law bought this small cottage in 1959. Interest in its restoration helped lead to the creation of the German Village Society. *The German Village Society.*

In the fall of '59, with work on the little cottage complete, Fetch talked a newspaper columnist into promoting an open house. On a chilly Sunday afternoon in November, an estimated five to eight hundred cars passed by the home, and about 125 people stopped to look inside. Most were impressed by what they saw, and many left their names and contact information on a sign-up sheet.

Less than two months later, on January 10, 1960, Fetch convened a meeting of people who shared his desire for South Side restorations. From this meeting sprang the nonprofit German Village Society, whose mission to promote historic preservation and educate the public about its benefits continues to this day.

And it all started with this tiny eight-hundred-square-foot cottage.

OUTSIDE THE HISTORIC DISTRICT

280 East Whittier Street
Recreation Park 2

From 1887 to about 1901, the northeast corner of East Whittier and Jaeger Streets drew nationwide attention to the Old South End.

In the late 1880s, the City of Columbus decided to move a large sports field known as Recreation Park from Mound and Parsons Streets (now the site of a highway interchange) to 280 East Whittier Street. Reassembling the old wooden pieces, builders created a grandstand that seated 5,000

This 1890s map shows Recreation Park 2 defined by Jaeger (west), Whittier (south) and Ebner (east) Streets. Kossuth Street marked the northern edge. *Franklin County Engineer's Office.*

171

spectators and bleachers to accommodate another 1,500. The new facility was crowned "Recreation Park 2"—or, as it became known, "Recky 2."

Early professional "base ball" teams took to the new field immediately. In 1887, it was home to the Columbus Senators. The Buckeyes (also known as the Solons) ruled from 1888 to 1891. The Columbus Reds owned the field in 1892, winning the first pennant for the city. And though Columbus did not become a big baseball city like Cleveland or Cincinnati, the sport did register a number of firsts here.

Recky 2 has been credited as having baseball's first concession stand, courtesy of Englishman Harry Stevens, who invented the baseball scorecard and who is often associated with the first hot dog. Sixty years before Jackie Robinson was hired as Major League Baseball's first African American player, African American J. Higgins played for the Columbus Senators. It has also been speculated that the famous baseball poem "Casey at the Bat" was written with Columbus Buckeye John "Patsy" Cahill in mind.

But professional baseball wasn't the only big game played at Recky 2. Football was introduced at the Ohio State University about 1890. And for the first couple seasons, the university's home games were played here. In fact, the Buckeyes lost their very first home game here on November 1, 1890, a Saturday afternoon. The mighty Wooster College beat the Buckeyes sixty-four to zero. By the way, for OSU fans, it was even worse than it sounds. Back then, touchdowns were worth only four points each instead of six.

For reasons unknown, Recky 2 didn't last long. It was gone by 1901, its wood sold for lumber. Over the next several years, the corner saw a lot of changes, but not nearly as much excitement. In the early 1940s, it housed a garage for Omar Bakery, which was located behind it on Kossuth Street.

The 1891 Ohio State University football team is seen playing one of its home games at Recreation Park 2 at East Whittier and Jaeger Streets. *Columbus Metropolitan Library.*

OUTSIDE THE HISTORIC DISTRICT

A Giant Eagle grocery and parking lot now occupy most of the land that was Recreation Park 2 in the 1880s and '90s. *Author's collection.*

The garage was destroyed in a spectacular nighttime fire just a few years later. Schmidt's Packing Company parked its trucks here for a few years. Old-timers remember a carnival that would set up here for a week each year. Some may recall a Sinclair gas station on this corner. And for many Decembers, it was a Christmas tree lot.

In the 1950s, the Columbus-based Big Bear Stores built one of its groceries here, and the lot has been home to a grocery ever since, in addition to, more recently, an Ohio historical marker proclaiming its place in Ohio State University football history.

BIBLIOGRAPHY

American Home Magazine (August 1964).

Arter, B. *Columbus Vignettes I*. N.p.: self-published, 1966.

———. *Columbus Vignettes II*. N.p.: self-published, 1967.

———. *Columbus Vignettes III*. N.p.: self-published, 1969.

———. *Columbus Vignettes IV*. N.p.: self-published, 1971.

Betti, Tom, Ed Lentz and Doreen Uhas Sauer. *Columbus Neighborhoods: A Guide to the Landmarks of Franklinton, German Village, King-Lincoln, Olde Town East, Short North and the University District*. Charleston, SC: The History Press, 2013.

C: The Columbus Magazine.

Campen, R. *German Village Portrait*. Chagrin Falls, OH: West Summit Press, 1978.

Cleveland Plain Dealer.

Columbus Citizen.

BIBLIOGRAPHY

Columbus Citizen-Journal.

Columbus City Directories

Columbus Dispatch.

Columbus Dispatch Magazine.

Columbus Monthly, January 1984.

The Descendants of Johann Adam Fornof. Self-published history of the Johann Adam Fornof family housed at the German Village Society.

Doody, S., and M. Rosen. *As the Tables Turn: Biography of a Bistro.* Wilmington, OH: Orange Frazer Press, 2006.

German Village Gazette.

German Village News, a German Village Society newsletter.

German Village Society Archives.

Graichen, Jody H. *Remembering German Village: Columbus, Ohio's Historic Treasure.* Charleston, SC: The History Press, 2010.

Jackson, Robert. "German Village Walking Tour Script." Unpublished, August 2005.

Kuhn, M.L. "203 East Beck Street." Unpublished, Ohio State University, 1995.

Maennerchor Gazette.

Mallett, Janay. "The Peerless Saw Company: 571–575 South Third Street." Unpublished, Ohio State University, 1995.

Moss, Kimberly. *Streets of Columbus.* N.p.: self-published, March 1996. Located at the German Village Society.

BIBLIOGRAPHY

Ohio Board of Charities. *Special Report to the Ohio Legislature: Condition of Buildings and Programs at the Franklin County Infirmary.* June 1868.

Ohio Historic Inventories, Ohio Historic Preservation Office, Ohio Historical Society.

Ohio Magazine.

Peerless Saw Company. *On This Corner in an Old German Village.* 571 South Third Street, Columbus, OH, n.d. Pamphlet located at the German Village Society.

Pen and Pencil Club. *Columbus, The Capital City: Newspaper Reference Book.* N.p., 1915.

Phase I Environmental Site Assessment: 570 South High Street, Columbus, Ohio. N.p.: Foust Engineering Inc., May 20, 2013.

Rippley, LaVern J. *The Columbus Germans.* Lawrence, KS: Max Kade German-American Center, 1998.

St. Mary's Golden Jubilee, 1851–1901.

Studer, Jacob Henry. *Columbus Ohio: Its History, Resources, and Progress.* Columbus, OH: self-published, 1873.

This Week Community News. *This Week German Village.* Various clippings cited.

Walley, Craig. "Deeds of Light von Gerichten Art Glass." *Timeline*, July/August 1998.

Walsh, Helen Bierberg. "The Bierberg Story: Four Generations." Unpublished manuscript located at the German Village Society.

INDEX

A

Actor's Theatre of Columbus 139
Adams, Catherine 54
Africentric High School 42
Alcorn Mansion 71
Alley Shop 91
Alvarez, Eleanor 76
Anderson, Benedict 11
Arledge, Russ 130
Arter, Bill 25

B

BalletMet 88
Bango, Julie 105
Barcelona Restaurant & Bar 153, 156
Barnum, Todd 129
Barrow, Jack 109
Barth, Henry 38
Baseball scorecard 172
Bauer, Ida 64
Baumann, Ferdinand 36, 147
Becker, Carl 62
Beck Place Condos 88
Beck Square 80
Behal, John 91
Behal Sampson Dietz 76, 90, 91
Berea College 107
Berkley Saloon 66
Bermuda Triangle 153
Best Wallpaper 62
Bierberg Bakery 102, 177
Bierberg, Emma and Gus 102
Bierberg, Ferdinand and Theresa 100
Big Bear Stores 173
Big Red Rooster 153
Bijou 98, 99
Book Loft 64, 67, 99
Boyer, Alice and Marion 81
Brontz, Marcella and Peter 29
brothel 119
Buckeyes, OSU football 172
Budros, Spencer 51
Burns, Howard 130
Busy Bee Confectionery 77

C

Cahill, John "Patsy" 172
Cambern, Brett and Andrea 76, 82

INDEX

Capital Soda Water Company 113
Capone, Al 119
Caretaker's Cottage 137, 139
"Casey at the Bat," poem 172
Caterina 51, 54
Central German-English Grammar School 42
Central Market 124
Chic Sale 104
Columbia Theater 100
Columbus Buckeyes 172
Columbus Maternity Hospital 47
Columbus Reds 172
Columbus Senators 172
Columbus Solons 172
Columbus Watch Company 151
Conway, Kathy 125
Cook, Lucille Gross 167
corncrib 19, 159, 160
Craw, Esther 153, 155, 156
Cup O' Joe 62

D

Daeumler and Olnhausen Saloon 69
Daeumler, Art 69
Daeumler's Grocery 69
Deibel, Bill 153, 154
Deibel's Restaurant & Bar 153, 154, 156
Deibel's Saloon 52
Diamond Savings Bank 62
Die Alte Süde Ende 20
Dill, Greenley 49
Dixon, Dr. and Mrs. Myrwood 54
Dollar Savings 116
Donley Homes, Incorporated 90
Doody Company 88
Doody, Sue 71
DrugEmporium.com 88
DuRivage, Donald and Mary 78

E

Ebner, Alois and Catherine 118
Echele, Bob 49, 83
Eddy, Jonathan 117
804 City Park Avenue 97
819–821 Mohawk Street 119
860 South Third Street 132
828 City Park Avenue 98
Elk, Myles 119, 121
Elk's Tavern 119
Engine House No. 5 151, 152, 153
Esselstein, Jerry 134

F

Ferris, Mike 49
Fetch, Frank 19, 25, 78, 80, 81, 84, 160, 169
filling stations 44
fire mark 37, 38
Fischer, Dorothy and Ralph 25, 28, 31, 40, 84
588 South Third Street 55, 61
550 South High Street 161, 163
555 City Park Avenue 29, 161
559 City Park Avenue 31, 32
551 City Park Avenue 27, 40
551 South Fifth Street 81, 87, 92
548 Mohawk Street 94
541 South Third Street 49
543 South Front Street 164
502 South Third Street 44
595 & 601 South Third Street 57
574–576 City Park Avenue 34
571 South Third Street 51
576 South Third Street 54
561 City Park Avenue 38
525 South Fourth Street 31
Flanigan, Joyce 125
Fletcher, Anne 51
Fornof, Johann Adam 139, 176

INDEX

41 West Columbus Street 159, 160
4S Club 100
43 East Kossuth Street 104, 105
Foster Gear Company 92
480 South Third Street 44
492 South Third Street 47, 84
Fourth Street Elementary 42
Franklin Art Glass Studios 93, 99, 121, 144
Franklin County Infirmary 157
Franklin Plating 95, 96
Fred and Howard (Fred Holdridge and Howard Burns) 130

G

Gambrinus Brewing Company 69
gas station 44
gay pioneers 86
Gease, Bob 49, 83
Germania 35, 164
German Village Commission 20, 46, 57, 90
German Village Meeting Haus 55
German Village Society 14, 20, 25, 27, 28, 55, 57, 59, 60, 61, 64, 80, 86, 116, 132, 147, 167, 170, 176
G. Michael's Bistro and Bar 59
Gochenbach, Katherine M. 94
Golden Hobby Shop 62, 63, 64
Greater Columbus Arts Council 64
Green, Mary Wirtz 134
Gross, Albert 167
Grosses Bakery 167
Grubbs, Albert P. 69
Gruen, Dietrich 149

H

Hartmann's Confectionery 77
Hausfrau Haven 130, 132
Heer Printing Company 42
Heimlich, Scott 156
Heintz, Dr. William 160
Helf, Elmore 121, 144
Helf, Gary 99
Helf, Henry 121
Helf, James 121
Hendricks, Mary Louise 132
Henry, Phil 154
Heyl, Christian 19
Higgins, J. 172
High Line Car House 163
Hodapp, Bernie 52
Holdridge, Fred 46, 73, 130
Hoster Brewery 37, 153, 160
hot dog, first 172
Hugus, William 57, 74, 82
Hurry, Bob 84, 85, 86, 87
Hurryville 84, 85

I

imagined communities 11
Isaly, Arthur H. 94
Isaly's 124, 125

J

Jacobsma, Carl 64
Juergen's Konditorei 31

K

Kaiser, Annie 127
Karb, Mayor George 47
Katzinger's Delicatessen 46, 153
Katz, Kyle 156
Kellenberger, Sarah 109
Keller's Doll Hospital 65
King, Joseph 37
King's Rose Garden 69
Kinzig, Augustus Wagner, and Krezenzia Baier 76
Klein's Drug Store 124
Klondike Bar 125

INDEX

Koehler, Frank 52
Kroger Grocery 66, 114
Kuehn, Edmund and Liese 98

L

Lamprecht, Tobias 127
Landry Seafood 153
Langins, Dr. Raymond 109
Lang, John and Sophia 88
Lang, Mathias 80, 88
Lang Stone Company 80, 81, 87, 88, 91, 92
Lilly, Ann 78
Lily Cinema 65
Lindenhof Restaurant 69
Lindey's Restaurant & Bar 69, 71, 73, 153
Littleton, Thomas 55
log house 27, 28, 40, 41, 42
Lorenz, John 43, 44
Lumpe, Bob 154

M

Maennerchor 35, 164, 165, 166, 167
Magnuson, Carl 62
Manda's Sinclair Station 47
Marble Cliff Quarry 87
Marianplatz 66, 67
Market-Mohawk 42
Marnie's Arts & Antiques 66
Martin, B.F. 102
Martin Carpet Cleaning 102, 103
Maurer, Amelia 64
Maurer's Saloon 64
Max & Erma's 37, 46, 121, 127, 129, 130, 153
McCutcheon, Dick 160
McDonald, John and Sally 91
McDowell, Lillian Gross 167
McGown, John 19, 31, 41, 117
McGown, Robert and Matilda 41

Mohawk School 42
Moose Lodge 55
Muer, Chuck 151, 152

N

National Register of Historic Places 20
Nature's Door 94, 95
Neil House Hotel 73
New Street School 135
967 City Park Avenue 135, 166
966–976 South High Street 164
Nixon, Frank 163, 164
Nixon, Richard M. 164
Noltemeyer, Eleanor and Ray 147
Nutcracker 62

O

Ohio Statehouse 147
Ohio State University, the 42, 107, 153, 172, 173
Oktoberfest 61, 147, 149
Old Mohawk 119, 121, 153
Old World Bazaar 29, 31
Olnhausen, Henry 35, 125, 126
Omar Bakery 172
180 East Beck Street 73
184 East Beck Street 75, 76
181 Thurman Avenue 141
150 East Kossuth Street 107
151 Jackson Street 42, 44
147 East Deshler Avenue 145
100 Reinhard Avenue 147
192 East Beck Street 76
169 East Beck Street 69
138 East Columbus Street 57
133 East Deshler Avenue 144
1000 City Park Avenue 137
1023 City Park Avenue 139
129 East Beck Street 26
121 East Beck Street 25

INDEX

121 Thurman Avenue 151
outhouses 104

P

Palmer House 69
Parkview Pharmacy 154
Parrish, Joe 78
Partlow, Charles 104
Peerless Saw Company 52, 53
Pellington Gallery 62
Peters Run 33
Petro, Angela 163
Phillips, Pat 69
Piggly Wiggly 154
Pistacia Vera 51
Plank, Will 50
poorhouse 157
Prohibition 65, 69, 114, 119, 127, 154

R

Railroad Savings & Loan 62
Recreation Park 2 153, 171, 172
Reihl, Henry 29
Reiner, Gottlieb "George" 50
Reiner's Doughnuts 50
Reiter, Barnhart 42
Retail Planning Associates 88
Robinson, Jackie 172
Rosenberger, John and Susan 97
Royse, Harry 160, 169
Roy's Phillips 66 46
Ruskin, John 23

S

Saile, John 139
Saturday Evening Post 40
Sauer, Adam 130
Sauer, Doreen Uhas 12
Saunders, John 105
Savage, W. J. 151

Scherrer, Betty and Terry 38
Schiller Park 137, 139, 145, 147, 149, 167
Schlee Brewery 37
Schlee, Nicholas 164
Schmidt, Geoff 110
Schmidt, George F. 110
Schmidt, J. Fred 110
Schmidt's Packing Company 173
Schmidt's Sausage Haus 33, 110, 113, 147
Schmitt, Frank 51
Schmitt, George and Margaret 31
Schmitt Saloon 52
Schmitt & Son Grocer 51
Schwartz Castle 47, 48, 49, 84
Schwartz, Friedrich Wilhelm 47
Schweinsberger, Heironymous 38
795 South Wall Street 104
791 Lazelle Street 113
769 South Third Street 130
767 South Wall Street 169
766 Mohawk Street 117
710–712 Jaeger Street 102
739 South Third Street 127
729 South Fifth Street 100
729 South Third Street 44
79 Thurman Avenue 149, 151
Shellabarger, Steve 114
Shively, Scott 116
Shumick, Tony 130
Siegle Daily Meat Market 52
Silcott, Tom 156
615 City Park Avenue 38, 40
650 South Third Street 123
645 City Park Avenue 40, 42
645 South Grant Avenue 88
673 Mohawk Street 116, 125
664 South Third Street 125
630 South Third Street 62, 124
639 Mohawk Street 115
631 South Third Street 64, 99

INDEX

632 City Park Avenue 64, 66
624 South Third Street 55, 60
627 South Third Street 61
Slaughter, Gene "Coach" 119
Southard, Marian 64
South End 21, 29, 34, 42, 52, 54, 62, 82, 95, 105, 123, 127, 132, 151, 160, 164, 169, 171
South High Car Barn 161
South Side 19, 21, 28, 43, 107, 159, 160, 170
South Sixth, Lear and Jaeger Streets 95
squirrel hunt 19
Starbucks 123, 125
Starling, Lyne 41
Stauf's 61, 62
Stevens, Harry 172
Stewart Avenue Elementary 135
Stewart, Francis 137
Stewart's Grove 137
Stiner, Helen 132
St. Mary's Church 62, 125
St. Mary's High School 116, 125
Substantial Building 65
Swabian Nightingales 34
Swiss Home Association 51
Swiss Singing Society 51

T

Taggart Management and Real Estate Services 90
Third Street German-English School 62, 124
387 East Beck Street 157
346 East Stewart Avenue 167
328 East Beck Street 84, 85
Thurmania 99
Thurn's Bäckerei 50
Tide House Saloon 69
tied house 69
Tiffany's 121

Tompkins, Roger 64
Trott, Petronella 80
Truberry Group 116
turtle soup 119
Two Caterers 163
280 East Whittier Street 171
259 East Whittier Street 153
252 East Beck Street 82
240 East Kossuth Street 110
244 Lear Street 92
205 Jackson Street 81, 88, 91
203 East Beck Street 77
263 East Whittier Street 153
228 East Beck Street 78
229 East Beck Street 80, 81, 88, 92
222 East Sycamore Street 121, 144

V

Victory Theater 100
Village Owl 64, 67
Visitors Center 57
Visocnik, Max and Erma 127
Vogel's Sinclair Service 47
Volz, Jacob 28
Von Gerichten Art Glass Studios 121, 123, 140, 143, 144
von Gerichten, Ludwig 140, 141, 142, 143
von Gerichten, Theodore 140, 141, 142, 143

W

Waldschmidt, John 57
Walter, Peggy and Robert 117
Ward Baking Company 88
Washington Park 137
Weilbacher Transfer Company 110
Weisheimer Companies 91
Wendy's Restaurants 121
Winn, Charles 52
Winnemore, Helen 107, 108, 109

INDEX

Wirtz Brothers Bakery 132
Wittenmeier, Friedrich 145
Wolf Tavern 66
Woodmen of America 55
Wooster College 172

Y

Young, Walter S., Filling Station 47
Yumet, Louis and Virginia 54

Z

Zacks, Barry 37, 129
Zang, Charles 96
Zettler's Grocery 118

ABOUT THE AUTHOR

John M. Clark is a twenty-three-year resident of German Village, having moved there from Houston with his wife, Jan, in 1992. The former German Village Society board member, longtime volunteer and current tour guide knows more about the history of this highly praised historic district than just about anyone.

His work for the society, in both paid and volunteer positions, has included writing and producing award-winning video presentations; videotaping seniors for the organization's ongoing oral history project; writing for "Neighbors for Neighbors," the weekly electronic newsletter; and photographing and videotaping many of the neighborhood's major annual events.

Courtesy of Tim Morbitzer.

In return, the society has honored Clark with the Fred & Howard Award for outstanding ambassadorship and service and the Village Valuable Award

ABOUT THE AUTHOR

for volunteerism. He and his wife were co-recipients of the Frank Fetch Award, the society's top honor, for service to the neighborhood.

Clark received his degree in journalism from Western Kentucky University, near his hometown of Scottsville, Kentucky, in 1979. Lengthy careers in broadcast journalism and retail advertising have helped shape his style of writing, described as straightforward, conversational and containing a gentle wit.

German Village Stories Behind the Bricks is his first book.

*Visit us at
www.historypress.net*

This title is also available as an e-book